?

MW00560325

POSTCARD HISTORY SERIES

Terre Haute & Vigo County

IN VINTAGE POSTCARDS

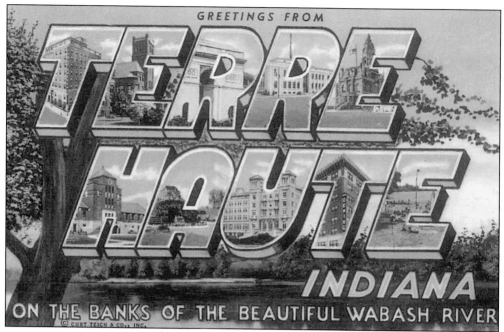

GREETINGS FROM TERRE HAUTE. Views shown on this 1946 card include: (T) Terre Haute House, (E) Administration Building at Indiana State Teachers College, (R) Memorial Stadium, (R) City Hall, (E) Vigo County Court House; also (H) ISTC Student Union Building, (A) Sunken Gardens at Fairbanks Park, (U) Le Fer Hall at Saint Mary-of-the-Woods College, (T) Deming Hotel, and (E) Izaak Walton Lake.

Front Cover Image:
INDIANA THEATER. This Spanish Baroque movie palace remains a downtown landmark on the southwest corner of Seventh and Ohio Streets. Designed for Theodore W. Barhydt by John Eberson, the 2,000-seat theater opened on January 28, 1922. The construction cost of the brick structure with terra cotta details and fabulous interior decoration exceeded $750,000. The marquee advertises two black and white silent films: the drama *You Can't Fool Your Wife*, released in 1923, and the comedy *Choose Your Weapons*, released in 1922.

Back Cover Image:
WABASH AVENUE, SHOWING TERRE HAUTE TRUST BUILDING AND TRIBUNE BUILDING. Automobiles have replaced horse-drawn vehicles in the scene on this card postmarked 1920. The Terre Haute Trust Building, completed in 1908 on the former site of Baur's Drug Store at 701 Wabash Avenue, dominates the "crossroads." The building became home of Merchants National Bank in 1934, and now houses the main banking office of Old National.

POSTCARD HISTORY SERIES

Terre Haute &

Vigo County

IN VINTAGE POSTCARDS

Dorothy W. Jerse

and

John R. Becker III

From the collections of John R. Becker III and Judith S. Calvert

ARCADIA
PUBLISHING

Copyright © 2001 by Dorothy W. Jerse and John R. Becker III
ISBN 978-0-7385-0747-7

Published by Arcadia Publishing,
Charleston, South Carolina

Printed in the United States of America

Library of Congress Catalog Card Number: 2001094616

For all general information contact Arcadia Publishing at:
Telephone 843-853-2070
Fax 843-853-0044
E-mail sales@arcadiapublishing.com
For customer service and orders:
Toll-Free 1-888-313-2665

Visit us on the Internet at www.arcadiapublishing.com

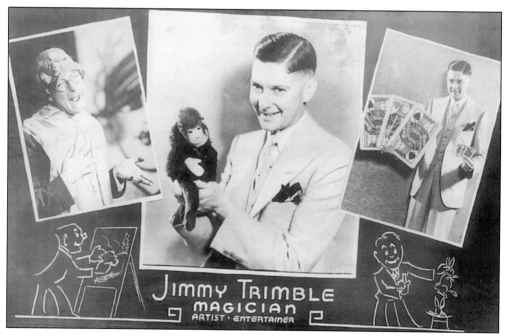

JIMMY TRIMBLE. James M. Trimble (1892–1971), founder of Trimble Sign Company, is portrayed as a magician, artist, and entertainer on this card used in 1936. His early interest in chalk artistry changed to magic, and he became well-known to audiences far and wide. He was a member of the International Brotherhood of Magicians and the Society of American Magicians.

CONTENTS

ACKNOWLEDGMENTS

The authors wish to thank the many individuals who helped make this volume a reality. The librarians and archivists, who have assisted with our research, are: Eileen Kelly, S.P., Sisters of Providence; Emily Walsh, S.P., Saint Mary-of-the-Woods College; Susan R. Davis, Indiana State University; Nancy Sherrill, David Lewis, and Mary-Margaret Iacoli, Vigo County Public Library; and John Robson, Rose-Hulman Institute of Technology.

Individuals who provided information include Robert W. Gropp, Mike Rowe, and Robert L. Smith. Marylee Hagan and Barbara Carney of the Vigo County Historical Society gave their personal support. B. Michael McCormick, Vigo County Historian, and Judith S. Calvert shared their research and editorial expertise.

Also, we are indebted to Richard and Lois Becker and to Bill Jerse for their continuing patience and support.

INTRODUCTION

This book is about Terre Haute and Vigo County, Indiana, as illustrated on picture postcards produced during the first 30 to 40 years of the twentieth century. By using only postcards to illustrate this chronicle of Terre Haute, a different glimpse is provided from the previous picture histories. These cards document the places, events, and people that were important to the residents of Terre Haute and to the tourists who passed through the city.

For most of the twentieth century, "the Crossroads of America" was literally at the intersection of U.S. 41 and the National Road (U.S. 40) at the corner of Seventh Street and Wabash Avenue. Although the crossroads has shifted to the southern end of the city with the building of I-70, Terre Haute is still a major transportation center perched on the high side of the Wabash River made famous by songwriter Paul Dresser.

The earliest picture postcards from Terre Haute were published by the Star Printing Company in the fall of 1898, following passage of an Act of Congress on May 19, 1898, allowing for Private Mailing Cards to be sent at the same 1¢ rate as the government postal cards beginning July 1, 1898.

Other local publishers soon fueled the growing craze, including William M. Bundy who had a local photography studio, John M. Heenan, E.L. Godecke, the Journal Printing Company, the Moore-Langen Printing Company, the New Central Pharmacy, C.M. Sparks, Viquesneys, and Leslie Whitton (who produced many of the real photo cards of the 1913 tornado and flood). Many of the best cards are the real photo cards, which seldom bear an indication of their maker.

Seeking higher quality printing, R.A. Weinstein and the Book Departments of Herz's Bazaar and the Root Dry Good Company contracted to buy cards from Raphael Tuck & Sons. Other local establishments soon followed, and thus began the era of mass produced cards made by the nationally-known postcard publishing companies such as the American News Company, the Indiana News Company, Tom Jones, S.H. Knox & Co., E.C. Kropp, I.&M. Ottenheimer, Rotograph, Curt Teich, the Valentine Souvenir Company, and other companies known by their stylized trademark logos. Many of the pre-World War I cards were printed in Germany due to their advanced printing technology.

The postcard craze began to wane in the 1920s, both in the quantity of cards produced and the quality of the printing. For the last half-century, postcards are nearly all of the "chrome" variety and show true and vibrant colors. These will be saved for a future volume along with more examples of an estimated 2,000 different view and printing combinations that have been produced for Terre Haute and Vigo County in the past century.

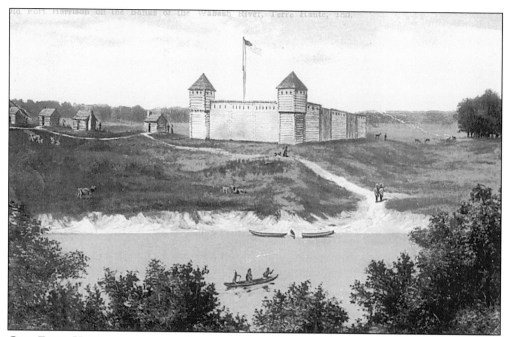

OLD FORT HARRISON ON THE BANKS OF THE WABASH RIVER. In 1811, General William Henry Harrison chose the site for Fort Harrison on the east bank of the river, north of the future location of the city of Terre Haute. Both Harrison and Captain Zachary Taylor, commander in 1812, became U.S. presidents. The fort was deactivated in 1818, but continued as a trading post. The Terre Haute Elks Club is located on the site.

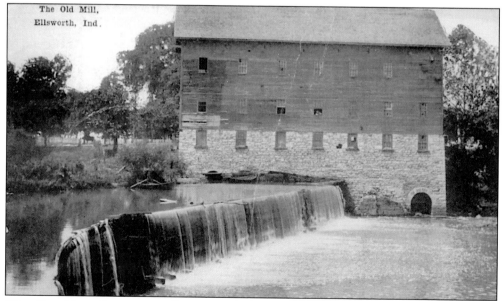

THE OLD MILL, ELLSWORTH, INDIANA. Abraham Markle, one of the men who scouted the Indiana Territory in 1815, returned in 1816 and began construction of this mill on Otter Creek. For many years it was the major business in North Terre Haute (formerly Ellsworth and Edwards). Fire destroyed the mill in 1938.

One

PUBLIC BUILDINGS
AND PLACES

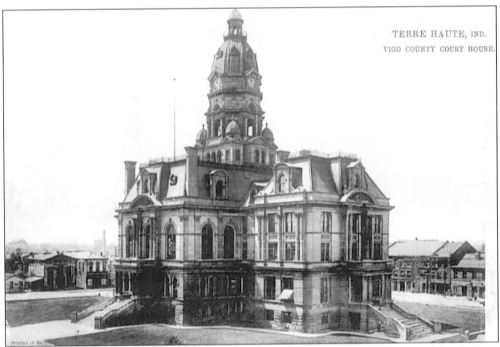

TERRE HAUTE, IND.
VIGO COUNTY COURT HOUSE.

VIGO COUNTY COURT HOUSE. The county was formed in 1818, and was named for Colonel Francis Vigo, a trader and supporter of General George Rogers Clark in his victorious efforts to win the Northwest Territory from the British. Terre Haute was designated as the county seat in 1818. Ground was broken for the present courthouse, pictured on this card in 1884 on the original courthouse square. Designed in Beaux Arts style by Samuel Hannaford of Cincinnati, the structure was completed in 1888. Funds to purchase the bell for the tower included a $500 gift from the estate of Francis Vigo.

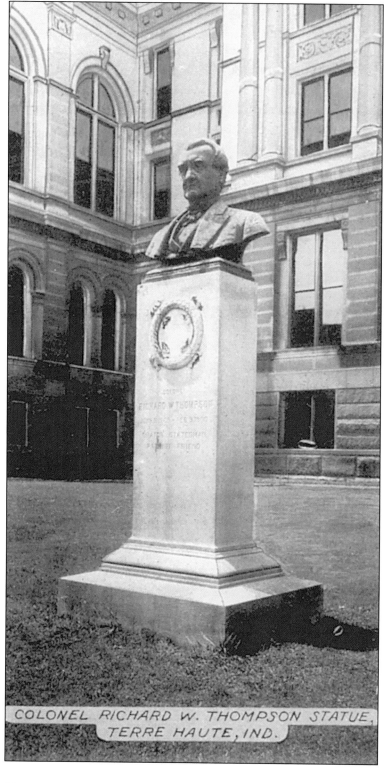

COLONEL RICHARD W. THOMPSON STATUE, TERRE HAUTE, IND.

COLONEL RICHARD W. THOMPSON STATUE. Col. Richard Wigginton Thompson (1809–1900), a native of Virginia, came to Indiana in 1831 and chose Terre Haute as his residence in 1843. He was a successful attorney, author, and orator active in the fields of government and education. He served in Congress, was the Secretary of the U.S. Navy, and the American chairman of the Panama Canal Co. Terre Haute, along with many other cities in the nation, mourned his death. All of the schools in the county were closed on the day of his funeral. The memorial bust of Col. Thompson, shown on this postcard used in 1914, was placed on the courthouse grounds in 1902. Col. William McLean said of Thompson, "Wherever he sat was the head of the table." Vigo County historian B. Michael McCormick wrote, "No Terre Haute citizen was more venerated."

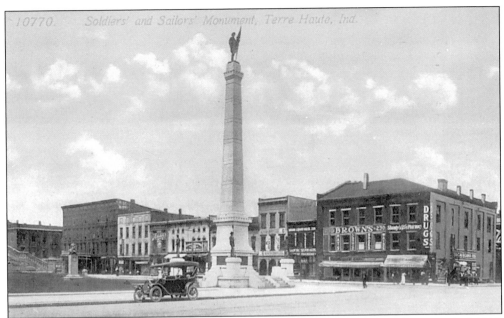

SOLDIERS' AND SAILORS' MONUMENT. The monument, pictured on this card postmarked 1913, is located on the northeast corner of the courthouse square. Indiana members of the Grand Army of the Republic dedicated it on May 25, 1910, to the memory of the Civil War unknown dead. Designer Rudolph Schwartz included statues of Indiana Gov. Oliver P. Morton (on top) and four figures representing artillery, cavalry, infantry, and navy men.

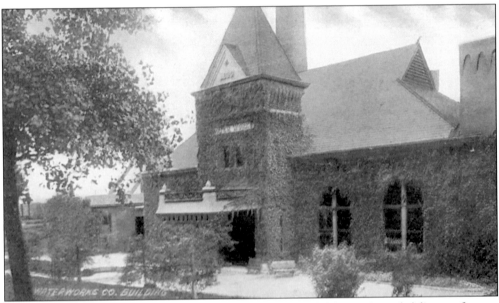

WATERWORKS CO. BUILDING. To meet the need for a reliable supply and delivery of water, community leaders decided on a privately owned and operated water supply system. The Terre Haute Water Works Company was incorporated and granted a franchise by the city in 1871. The company building, pictured on this card, was constructed about 1900 on Water Street at Tippecanoe Street on the east bank of the Wabash River.

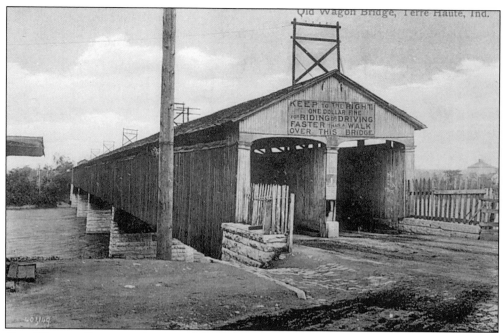

OLD WAGON BRIDGE. This bridge across the Wabash River was used from 1865 to 1903. Constructed as a toll bridge by the Terre Haute Drawbridge Co., the raised drawbridge allowed the passage of steamboats. It was purchased by the county in 1874 and made a free bridge. The sign reads, "Keep to the Right. One Dollar Fine for Riding or Driving Faster than a Walk Over This Bridge."

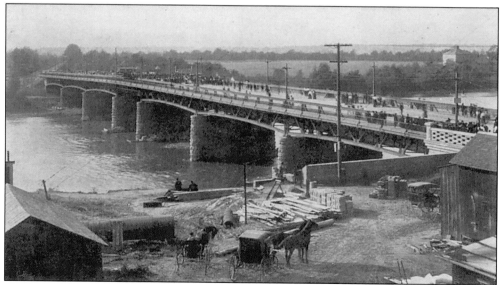

THE NEW WABASH BRIDGE. Constructed at a cost of $271,000, this bridge replaced the old wagon bridge. The cost included removal of the old bridge in 1904, and the construction of a temporary one. Designed by Malverd A. Howe of Rose Polytechnic Institute and James E. Starbuck of the Vandalia Railroad, the new steel bridge opened in 1905, and was in use until the present twin bridges opened in 1992.

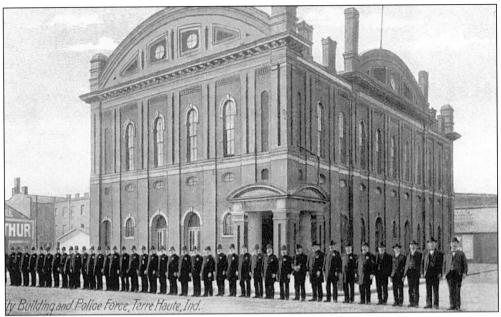

CITY BUILDING AND POLICE FORCE. Constructed in 1873–74, this building at the northwest corner of Fourth and Walnut Streets served as city hall from 1877 to 1937. The Terre Haute Police Department, shown here early in the century, occupied the main floor. Condemnation of the building and its demolition led to the construction of a new city hall in 1936.

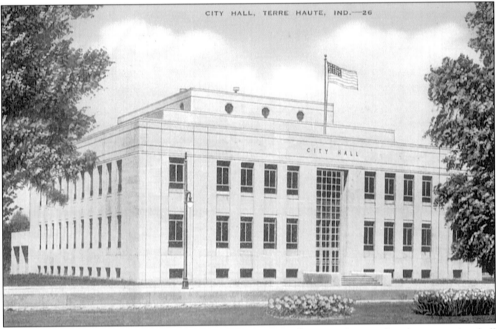

CITY HALL. A parade from the Masonic Temple to the site chosen for the new city hall preceded the cornerstone ceremony on August 22, 1936, for this federally funded building. Samuel Beecher Sr., was the mayor at the time. This modernistic structure at 17 Harding Avenue, designed by Miller and Yeager, continues to be the home of city government.

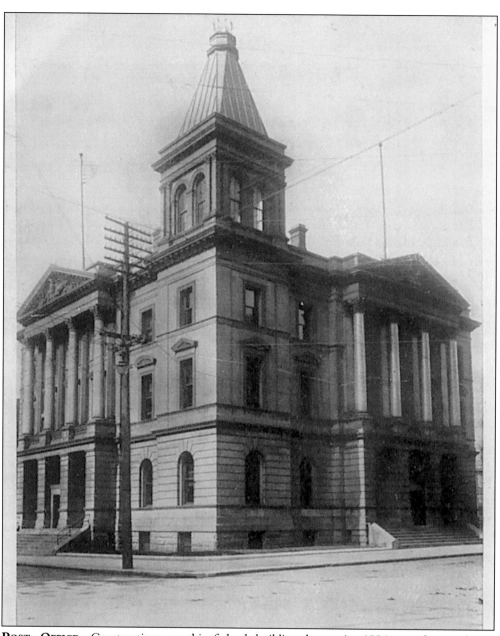

POST OFFICE. Construction on this federal building began in 1884, on the southwest corner of Seventh and Cherry Streets on land purchased by the U.S. Government from William Riley McKeen in 1883. Benjamin F. Havens, former mayor of Terre Haute, was appointed by President Grover Cleveland to be the construction superintendent. The structure, completed in 1887, was the first local building designed to accommodate both a post office and federal offices. A bronze marker set in stone on the east side of the building read "U.S. Geologic Survey—elevation above sea level, 513 feet." Work to raze the structure began May 27, 1932, by the R.C. Goldman Wrecking Company to make way for the present federal building, which opened in 1935. The columns and triangular entablatures were moved to Fairbanks Park, where they became part of the Chauncey Rose Memorial, dedicated in 1936.

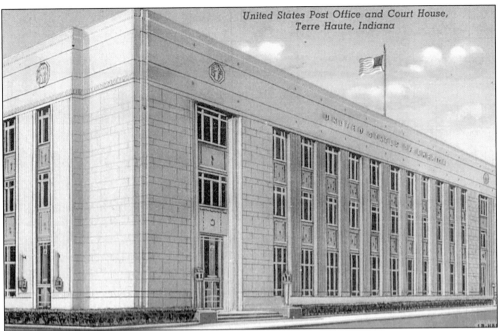

UNITED STATES POST OFFICE AND COURTHOUSE. Designed in the Art Deco style by Miller and Yeager and constructed on the site of the first federal building and the Paul Kuhn property to the west, this building opened in 1935. Major postal operations were moved to the south side of the city in 1997; but in 1999, members of Save the Architecturally Magnificent Postal Station (STAMPS) succeeded in keeping postal service in this building.

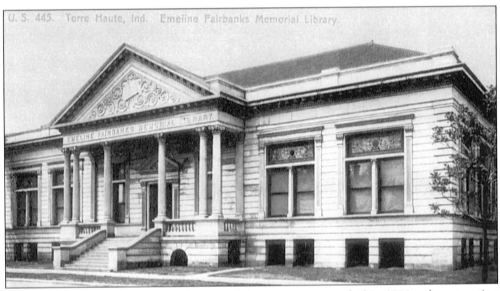

EMELINE FAIRBANKS MEMORIAL LIBRARY. The cornerstone was laid in 1904 and construction completed at the corner of Seventh and Eagle Streets in 1906, using an $80,000 contribution from Crawford Fairbanks given in memory of his mother, Emeline Fairbanks. It served patrons until 1979, when a new Vigo County Public Library building opened at One Library Square. The Fairbanks Library building is now a part of the Indiana State University campus.

15

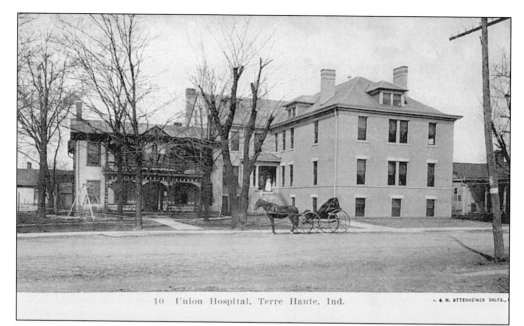

10 Union Hospital, Terre Haute, Ind.

I. & M. OTTENHEIMER BALTO.,

UNION HOSPITAL. Terre Haute physicians Dr. L.J. Weinstein and Dr. B.F. Swafford purchased the Stewart farmhouse, located on the northwest corner of Seventh Street and Eighth Avenue, in 1892 for the Terre Haute Sanitarium. It became Union Hospital in 1897. A three-story brick addition that was completed in 1902 appears in this 1906 view. The original frame building was razed in 1909.

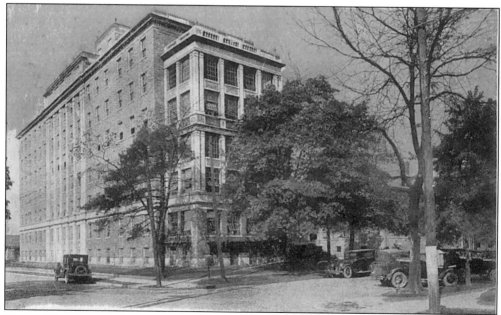

UNION HOSPITAL. A fund-raising campaign was launched in 1920 to enlarge the hospital. Two years later, the new South Wing was constructed, as shown on this card postmarked 1924. The first two floors were equipped and occupied when the building opened. As more funds were raised, additional floors were made ready for patients.

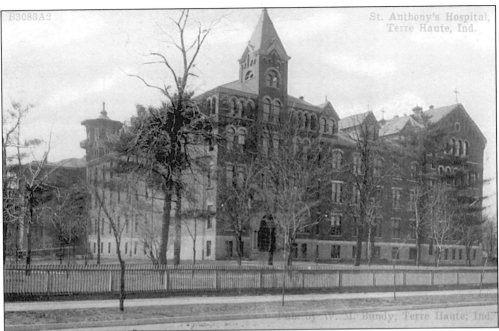

ST. ANTHONY'S HOSPITAL. In 1883, Herman Hulman Sr. bought the property once occupied by Saint Agnes Hall, a female seminary, at Sixth Street and College Avenue. The remodeled facility opened in 1884 as St. Anthony Hospital, a memorial to his wife, Antonia. A new wing and a Sixth Street entrance were added in 1901, and other major additions were constructed between 1908 and 1913.

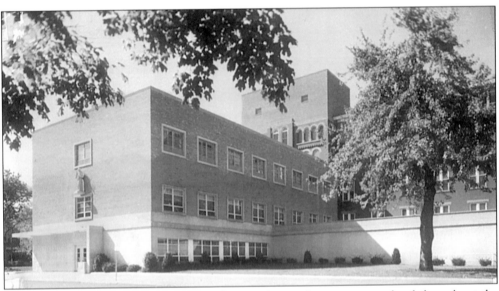

ST. ANTHONY HOSPITAL. Expansion and renovation projects were completed throughout the history of the hospital. Acquired by the Hospital Corporation of America in 1975 from the Poor Sisters of St. Francis Seraph, the facility was closed in 1979, after the opening of the new Terre Haute Regional Hospital. The buildings were razed in 1982. Anthony Square, a complex for older persons, is now located on the site.

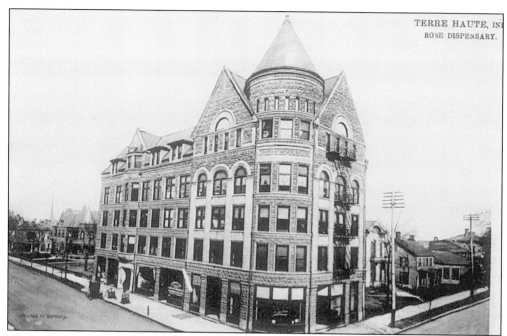

ROSE DISPENSARY. This imposing structure at Seventh and Cherry Streets was constructed in 1894–95. The dispensary provided free medical services to those in need using funds left for that purpose by Chauncey Rose. Indiana State University purchased the building in 1970, and razed it in 1972. The site is now Oakley Plaza, the North Seventh Street entrance to the campus.

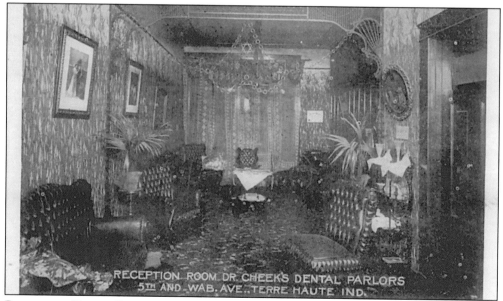

RECEPTION ROOM, DR. CHEEK'S DENTAL PARLORS. Dr. John H. Cheek, a native of Terre Haute and an 1898 graduate of the Indiana Dental College of the University of Indianapolis, had the "most spacious and complete dental parlors" in the city. His office was located on the second floor of the Erwin Block at the northeast corner of Fifth Street and Wabash Avenue. The card is postmarked 1907.

18

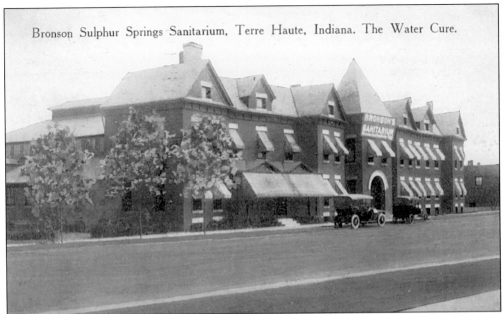

Bronson Sulphur Springs Sanitarium, Terre Haute, Indiana. The Water Cure.

BRONSON SULPHUR SPRINGS SANITARIUM, THE WATER CURE. Described as "a fortune from a misfortune," a company drilling for oil in 1889 struck artesian water instead on the property of David Bronson. He built this health resort on the site. First known as the Exchange Artesian Springs and Bath House, it was located at 207 North Ten and One Half Street opposite the Union Railroad Station. It was partially destroyed by fire in 1921.

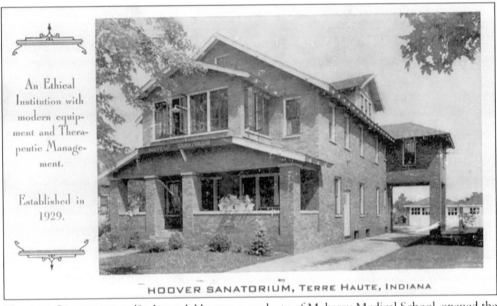

An Ethical Institution with modern equipment and Therapeutic Management.

Established in 1929.

HOOVER SANATORIUM, TERRE HAUTE, INDIANA

HOOVER SANATORIUM. Dr. James J. Hoover, a graduate of Meharry Medical School, opened the Hoover Sanatorium in 1929, the first hospital for African Americans in the city. After his death in 1953, the institution was operated until 1959 by his son, Dr. Dewey A. Hoover. The building at 2144 Eighth Avenue then was leased and operated as an integrated convalescent home.

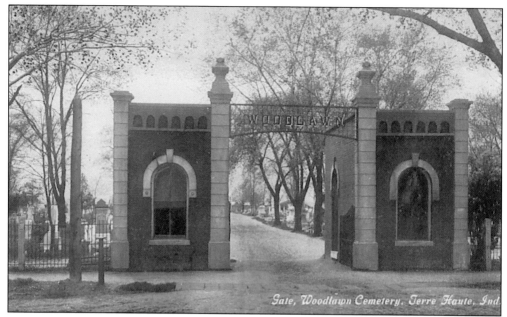

Gate, Woodlawn Cemetery, Terre Haute, Ind.

GATE, WOODLAWN CEMETERY. Known first as "City Cemetery," the grounds at 1230 North Third Street opened for burials in 1839. Some of the first bodies were transferred there from the Indian Orchard burying ground and from a graveyard at the corner of Sixth and Ohio Streets. An obelisk marks the burial place of 11 Confederate soldiers who died in Terre Haute while prisoners of war.

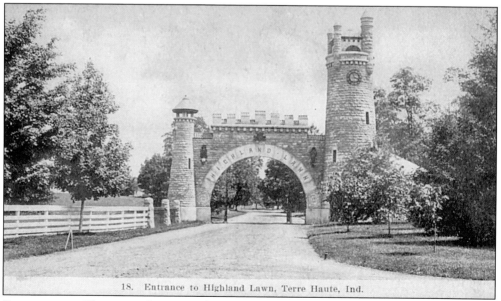

18. Entrance to Highland Lawn, Terre Haute, Ind.

ENTRANCE TO HIGHLAND LAWN. As the population grew, it was believed Woodlawn Cemetery, the older city cemetery, would soon reach its capacity. Therefore in 1884, the city council purchased the Jenckes family farm, east of Terre Haute on U.S. 40, for a second cemetery to be known as Highland Lawn. The Bedford limestone bell tower and gateway arch shown here were constructed in 1894 and renovated in 1990.

20

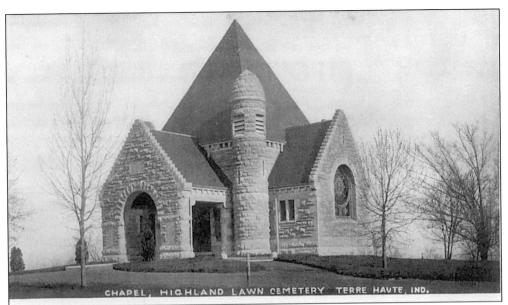

CHAPEL, HIGHLAND LAWN CEMETERY. The chapel, designed by Josse A. Vrydagh and completed in 1893 at a cost of $10,000, is located on the crest of a hill on the cemetery grounds. It is an example of Richardsonian Romanesque architecture popular at the time. Renovation of the structure began in 1987, and was completed in 1988 at a cost of $65,000.

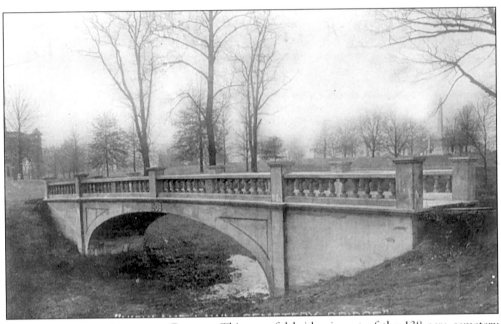

HIGHLAND LAWN CEMETERY BRIDGE. This graceful bridge is part of the 138-acre cemetery designed in 1884 in Romantic landscape style by Joseph Earnshaw. The "lawn plan," as opposed to the erection of large monuments, included selective placement of water, vistas, and plantings. It was the second cemetery in the state of Indiana to be accepted on the National Register of Historic Places.

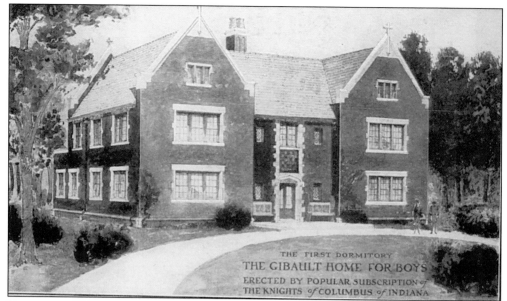

THE FIRST DORMITORY
THE GIBAULT HOME FOR BOYS
ERECTED BY POPULAR SUBSCRIPTION of
THE KNIGHTS of COLUMBUS of INDIANA

THE FIRST DORMITORY, THE GIBAULT HOME FOR BOYS. Gibault Home for Boys, established by the Indiana Knights of Columbus, opened in 1921 on the former Fred B. Smith estate south of Terre Haute. It was named in honor of Father Pierre Gibault, a supporter of George Rogers Clark in his fight against the British. The first dormitory, shown above, was erected in 1922 by popular subscription.

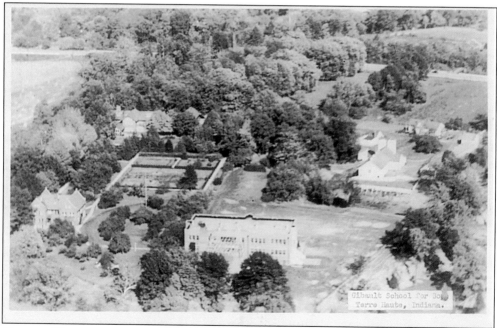

Gibault School for Boys
Terre Haute, Indiana.

GIBAULT HOME FOR BOYS. This aerial view shows the expansion of the campus. The school operated under the administration of the Brothers of the Holy Cross from Notre Dame from 1934 to 1981, when a board of trustees was formed. The original mission of the school to serve as a "refuge for wayward boys" was broadened when the first girls were admitted in 2001.

22

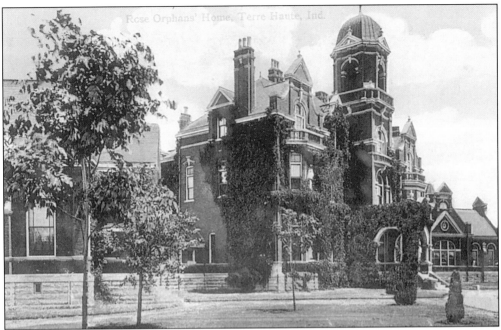

ROSE ORPHANS' HOME. Later known as Chauncey Rose School, this home for children was founded with a bequest from philanthropist Chauncey Rose. Designed by Samuel Hannaford, it opened in 1884 on the northeast corner of Twenty-fifth Street and Wabash Avenue. The institution was closed by 1950, when the main building became a home for the aged. The property was sold in 1965 and razed the next year to make way for a K-Mart shopping center.

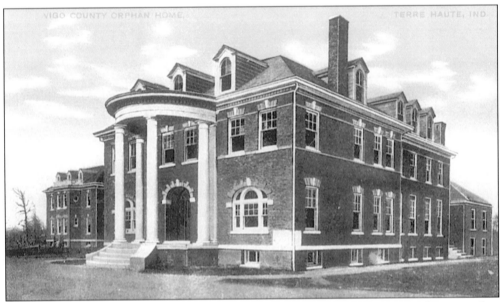

VIGO COUNTY ORPHAN HOME. This institution was the Vigo County Home for Dependent Children, not an orphanage. Located on the former Klatte farm, the facility became known as the Glenn Home and was in use from 1903 to 1979. It is now the home of the Pi Kappa Alpha Fraternity chapter at Rose-Hulman Institute of Technology.

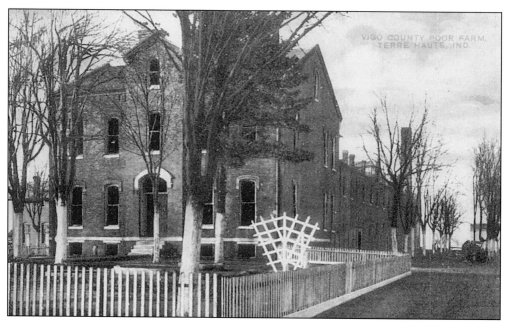

VIGO COUNTY POOR FARM. The first county home, built in 1853 east of the city on Poplar Street, was replaced in 1866 with a home northeast of the city. In 1925, 61 men and 26 women called the structure pictured on this card "home." A new Vigo County Home on the same Maple Avenue location was built in 1936. It is now the site of Royal Oaks Healthcare Center.

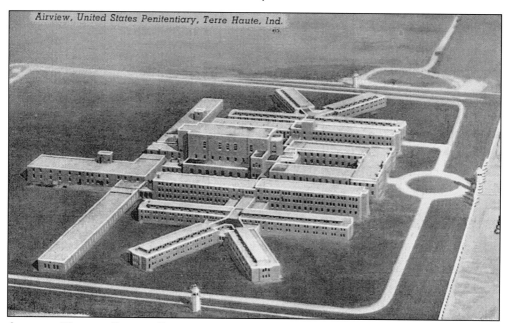

AIRVIEW, UNITED STATES PENITENTIARY. Land in Honey Creek Township south of Terre Haute was selected as the site for a medium-security penitentiary in 1938. Dedication took place on October 3, 1940. A minimum-security camp was added to the complex in 1960. Annexation brought the area into the city in 1989. The facility was named home to the federal death row in 1993. The execution facility, completed in 1995, was first used on June 11, 2001.

Two

STREET SCENES

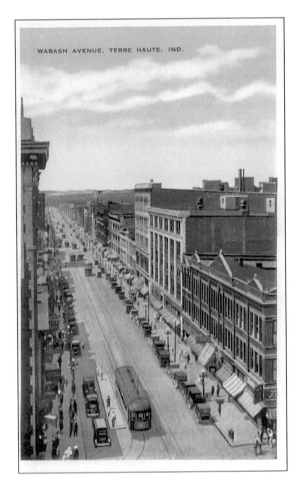

WABASH AVENUE, TERRE HAUTE, IND.

WABASH AVENUE. Parking was at a premium on this day in downtown Terre Haute in the 1930s. Looking west down Wabash Avenue from Seventh Street, the Fairbanks Building at 672–678 Wabash Avenue, constructed as the McKeen Block in 1885, appears in the lower right corner. Hook's Drugs occupied the corner store. The building was razed in 1965 to make space for a parking lot. The lot was closed in 1986 to make way for the construction of the new IBM office building. It is now occupied by the Vigo County School Corporation administration.

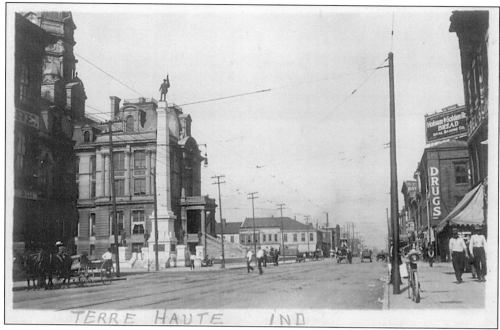

WABASH AVENUE, LOOKING WEST. The photographer for this view, postmarked 1913, was standing on the north side of Wabash Avenue between Third and Fourth Streets. The Civil War monument on the courthouse lawn appears on the left. Shandy's Court House Pharmacy is at the corner. A billboard for the Ideal Baking Company's Holsum Bread and a sign for the Stag Hotel appear along the north side of Wabash Avenue.

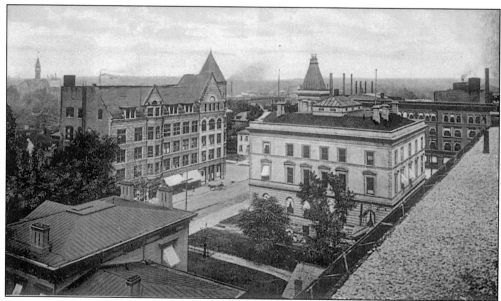

BIRDS-EYE VIEW. This card, postmarked 1909, looks from the southwest to the northeast at the intersection of Seventh and Cherry Streets. It shows the Rose Dispensary Building on the left, the Federal Building and the adjacent Paul Kuhn property in the center, and the Grand Opera House on the right.

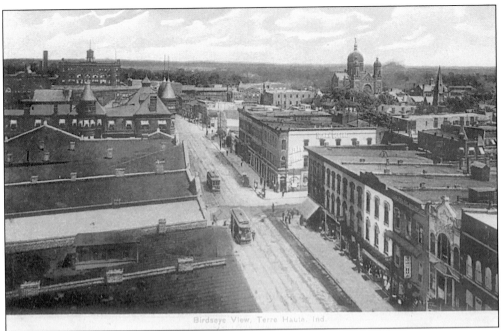

BIRDS-EYE VIEW. This view is looking east along Wabash Avenue from Sixth Street. The ornate facade of the United States Trust Company, built in 1904 at 643 Wabash Avenue, appears on the right corner of this view. After a 1927 merger, it became the main office of Terre Haute First National Bank. The Greater Terre Haute Chamber of Commerce, the Alliance for Growth and Progress, and the Terre Haute Convention and Visitors Bureau now occupy the building.

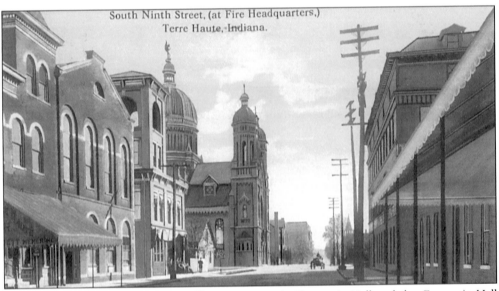

SOUTH NINTH STREET (AT FIRE HEADQUARTERS). Germania Hall and the Germania Hall Saloon, 18–20 South Ninth Street, are located to the left of the fire department headquarters at 28 South Ninth Street. St. Benedict's Catholic Church dominates the southeast corner of Ninth and Ohio Streets. The church and fire station remain in use; the Esten Fuson building occupies the site of Germania Hall.

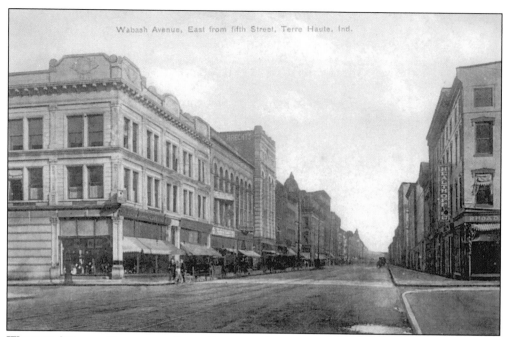

WABASH AVENUE, EAST FROM FIFTH STREET. The Erwin Block, housing Tune Brothers men's store, appears on the northeast corner in this scene. "Bob W.," the sender of this card in 1909 to a "Miss" in Syracuse, New York, wrote: "Hello Love, This is where I am now—a fine city." The corner is now the site of the transfer station for the Terre Haute Bus Lines.

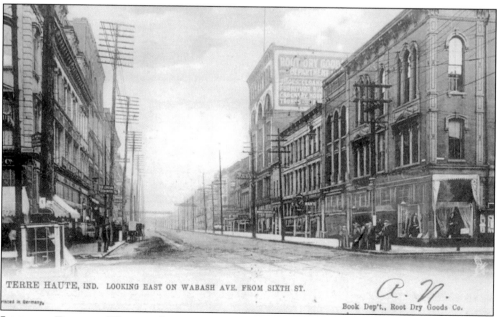

TERRE HAUTE, IND. LOOKING EAST ON WABASH AVE. FROM SIXTH ST.

Book Dep't., Root Dry Goods Co.

LOOKING EAST ON WABASH AVE. FROM SIXTH STREET. This view, postmarked 1907, gives a truer picture of downtown Terre Haute because the utility poles and lines are not blocked out. The seven-story Root Dry Goods department store stands out at 617–621 Wabash Avenue. By 1915, the store employed 325 persons and had 13 wagons and 23 horses in use.

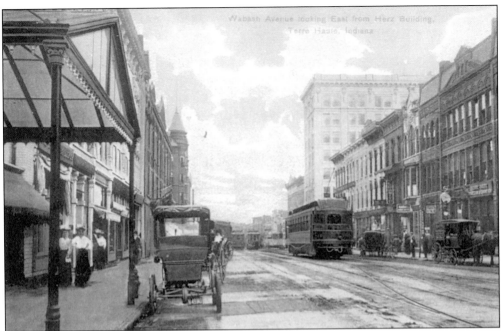

WABASH AVENUE LOOKING EAST FROM HERZ BUILDING. The elaborate entrance to the Herz store, 646–652 Wabash Avenue, marks the beginning, and the Terre Haute House the end, of the business buildings shown on the north side of Wabash Avenue. The Terre Haute Trust Building stands above the others on the south side.

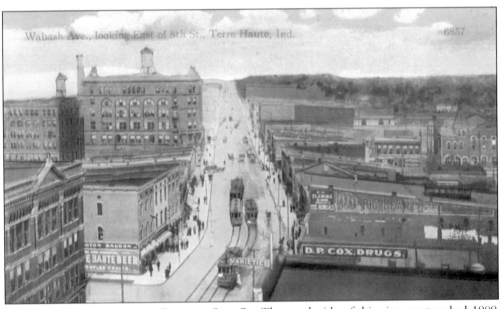

WABASH AVENUE LOOKING EAST OF 8TH ST. The north side of this view, postmarked 1909, begins with the Bement-Rea wholesale grocery building, shows Stuempfle & Welte's Washington Saloon, and ends with the Hulman & Company buildings opened in 1893. Signs for the Varieties Theater, D.P. Cox Drugs, and Fleming & Son High Bred Horses appear on the south side.

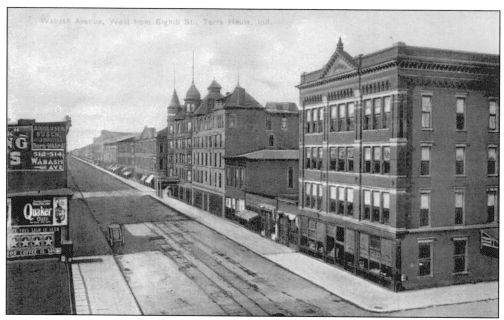

WABASH AVENUE, WEST FROM EIGHTH ST. The Rea Block on the northwest corner, built in 1889 for the Bement-Rea wholesale grocery firm, is shown before the business was moved to a new building at 30 North Eighth Street in 1910. The Lyric Theater (later the new Orpheum), 720–722 Wabash Avenue, was located in the middle of the block.

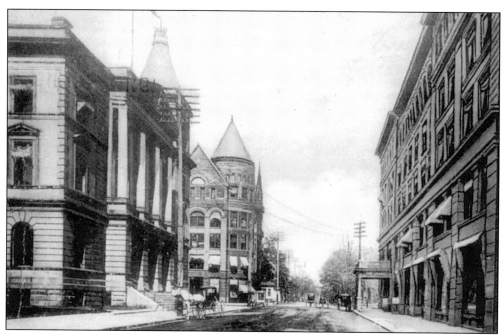

LOOKING NORTH ON SEVENTH STREET FROM WABASH AVENUE. The three corners of the intersection of Seventh and Cherry Streets include the federal building and post office on the southwest, the Rose Dispensary on the northwest, and the Grand Opera House on the southeast. The card was part of a Herz Store series issued early in the twentieth century.

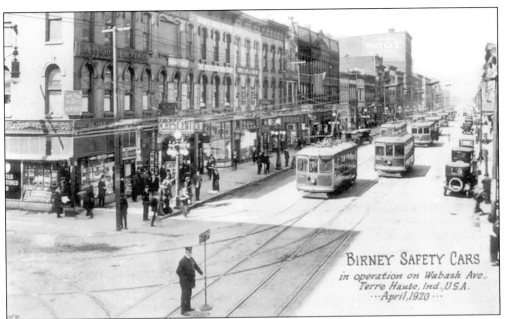

BIRNEY SAFETY CARS IN OPERATION ON WABASH AVE., APRIL, 1920. The traffic officer stopped vehicles traveling on Seventh Street to give the right-of-way to the Birney streetcars on Wabash Avenue. Signs on the southwest corner include United Cigar Stores, Patsy Mahaney's Candies, the Crescent Theater, and Doctor Frank Anshutz, dentist.

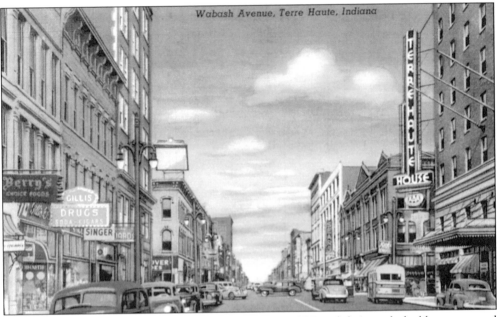

WABASH AVENUE. Buses had replaced the streetcars in 1939, and their tracks had been removed by the time this scene was photographed in the 1940s. Signs for Berry's Choice Foods, Gillis Drugs, and Singer Sewing Machines appear on the left. Businesses on the Seventh and Wabash "crossroads" corner were Hook's Drug (northwest), Hanover Shoes (southwest), Merchants National Bank (southeast), and the Terre Haute House (northeast).

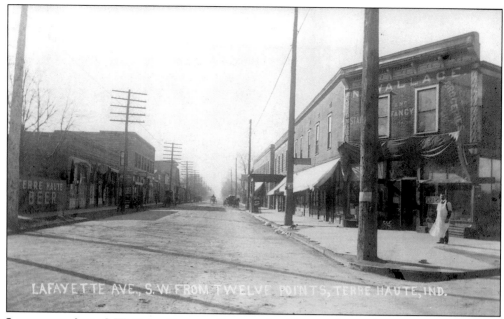

LAFAYETTE AVE. S.W. FROM TWELVE POINTS. Looking southwest from Maple Avenue, this early scene shows the Twelve Points business section, which Walter Phillips began developing in 1897. Nathan G. Wallace owned the grocery store on the right advertising "fresh oysters." A Tobacco Road convenience store is now located on the site.

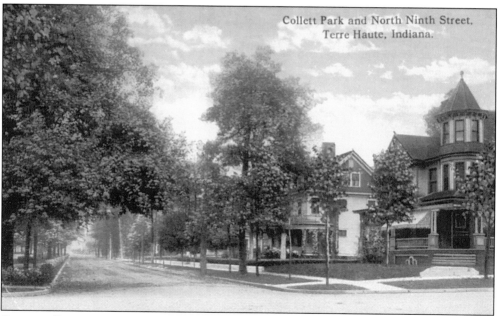

COLLETT PARK AND NORTH NINTH STREET. This tranquil scene pictured on a card postmarked 1912 shows a part of the Collett Park neighborhood. As the city expanded in the early 1900s, the beauty of the park attracted the construction of large, gracious homes around its perimeter. A number of the early residents were Rose Polytechnic Institute professors and their families.

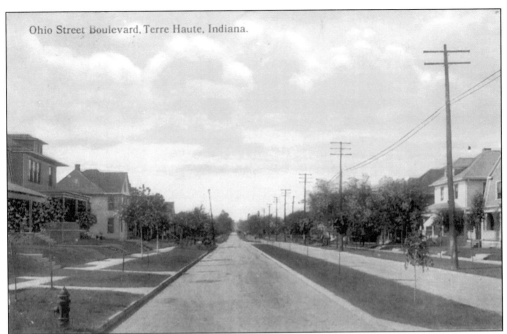

Ohio Street Boulevard, Terre Haute, Indiana.

OHIO STREET BOULEVARD. Ohio Street, in the downtown area, was a broad business thoroughfare, second only to Wabash Avenue. As one traveled east, the boulevard became part of a residential area. This card, postmarked 1916, looks west from Nineteenth Street along Ohio Street. The narrow boulevard shown here has since been removed, but the wider boulevard east of Nineteenth Street still remains.

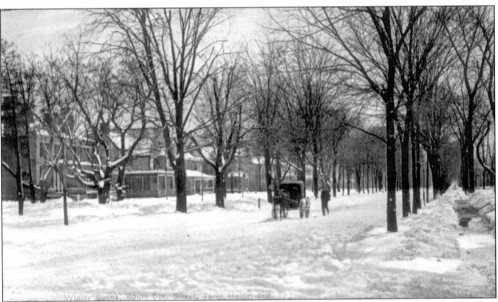

WINTER SCENE, SOUTH SIXTH STREET. *The Terre Haute Express* (1900) described the southern part of the city as "laid out in spacious residential sites. . . representing the substantiability of the community. Along Fifth, Sixth, and Seventh Streets, the shade trees have grown in such a luxuriousness that the boughs meeting overhead form archways."

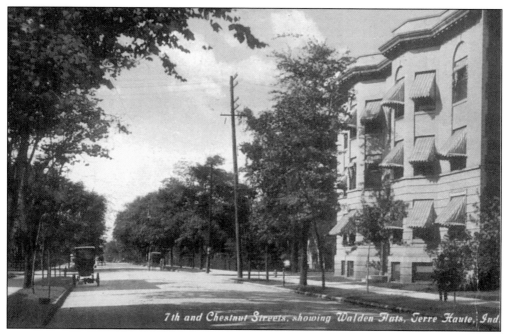

7th and Chestnut Streets, showing Walden Flats, Terre Haute, Ind.

7TH AND CHESTNUT STREETS, SHOWING WALDEN FLATS. "The Walden" was ready for occupancy on October 1, 1904. Six- and seven-room apartments with bath, hot and cold water, and steam heat were available. Razed in 1988, the site is now a part of the Indiana State University campus.

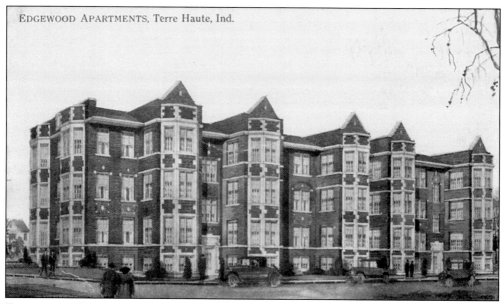

EDGEWOOD APARTMENTS, Terre Haute, Ind.

EDGEWOOD APARTMENTS. The Edgewood Apartment Corporation was incorporated in 1923, with plans to erect the Edgewood Cooperative Apartments. Completed by 1925 by the North-Raffin Construction Company, the building is located in Edgewood Grove, the city's first twentieth-century suburban subdivision, developed in 1911 on the south side of Wabash Avenue east of Brown Avenue.

THE FLORENCE CRITTENTON HOME. The home, shown in this Martin photo at 1923 Poplar Street, offered a "place for supervisory care of unmarried girls prior to delivery and during later convalescence." It opened in 1907 and closed in 1972. The property was sold in 1973, and the organization was dissolved by the board of directors in 1975.

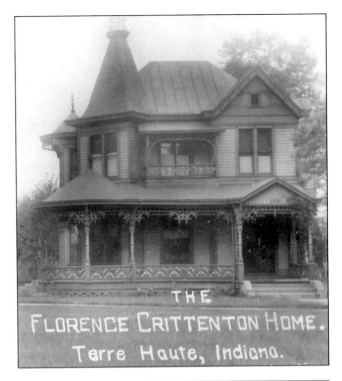

CLARA FAIRBANKS HOME. Crawford Fairbanks, Terre Haute industrialist, purchased the Scott homestead at Seventh Street and Eighth Avenue in 1920 for the Women Order Retail Druggists to continue their care of aged women. Four years later, he built this new home on the same site in memory of his wife, Clara Collett Fairbanks. The doors closed in 1986, after the residents were relocated to other facilities. A Union Hospital parking lot now occupies the site adjacent to the Clara Fairbanks Women's Center.

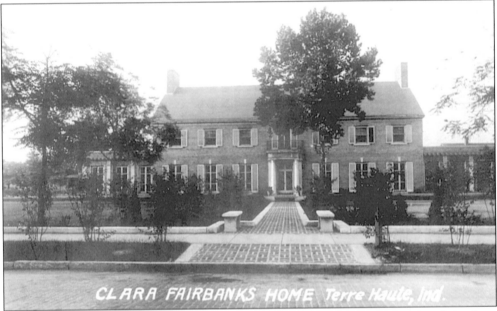

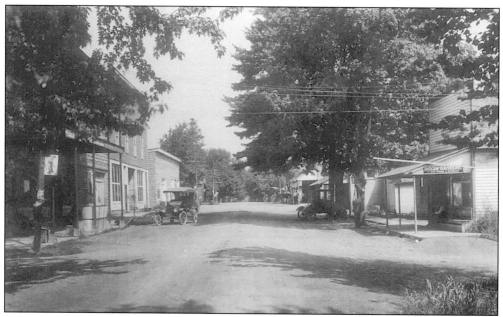

BUSINESS STREET, PRAIRIE CREEK. This is the largest community in Prairie Creek Township, which is located on the Wabash River in the southwest corner of Vigo County. First known as Middletown, the town was laid out in 1831 by James D. Piety on the Vincennes wagon road. Shown in the early 1920s, the business at the right features a single Indian Gasoline pump.

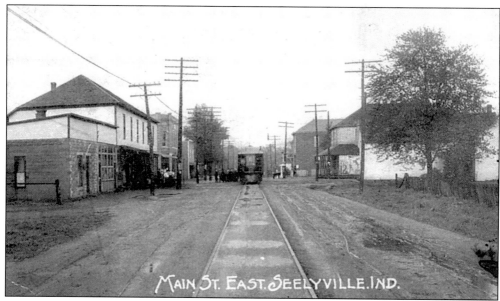

MAIN STREET EAST, SEELYVILLE. A part of Lost Creek Township, Seelyville is located 8 miles east of Terre Haute on the National Road (U.S. 40). It was described as "a mining camp and producer of coal in abundance" in 1912. The community was served by the Vandalia Railroad and the Terre Haute, Indianapolis & Eastern interurban line from Terre Haute to Indianapolis.

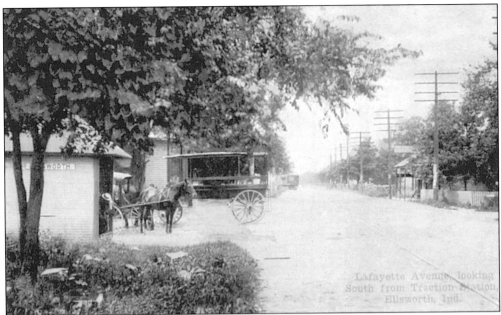

LAFAYETTE AVENUE, LOOKING SOUTH FROM TRACTION STATION, ELLSWORTH. Postmarked 1911, this card pictures the Ellsworth Station on the Terre Haute, Indianapolis & Eastern interurban line to Clinton. The community's name is derived from the Ellsworth Paper Co., established in 1888. Later the name was changed to Edwards and then to North Terre Haute.

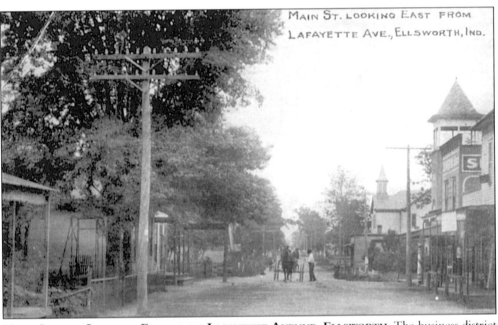

MAIN STREET, LOOKING EAST FROM LAFAYETTE AVENUE, ELLSWORTH. The business district appears on this card used in 1910. The bell tower of the North Terre Haute Christian Church and the cupola of the Ellsworth Schoolhouse appear on the right side of Main Street, now East Park Avenue.

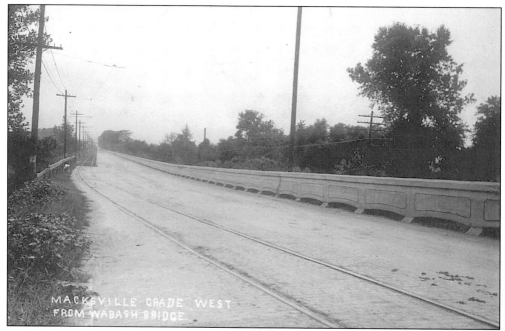

MACKSVILLE GRADE WEST FROM WABASH BRIDGE. The National Road connected Terre Haute and Macksville (West Terre Haute). This grade west of the river was guarded with a long concrete fence on the north side. Traffic included streetcars and interurbans. The guard fence appears on the right of this card, and parts of it may still be seen along the road.

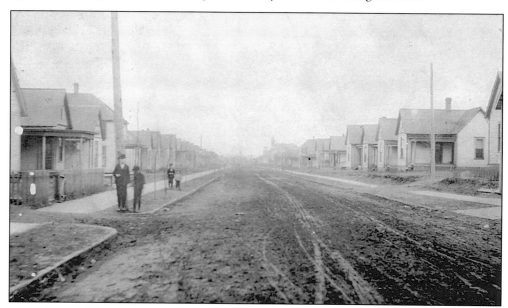

WEST TERRE HAUTE. This unidentified street is evidence of the building boom reported in 1907. Lots were at a premium. The 1910 census (3,083) showed a large increase in population of the town. Work at the coal mines and clay industries prompted West Terre Haute newspaper publisher Frank McDonald to describe the town as a "prosperous, progressive, full-dinner-pail, pay-roll city" in 1918.

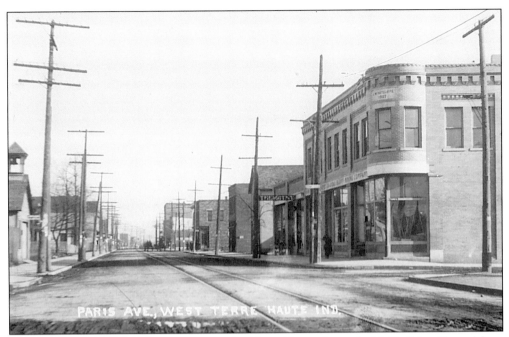

PARIS AVENUE, WEST TERRE HAUTE. West Terre Haute, formerly McQuilkinsville and later Macksville, is located on the west side of the Wabash River. The tracks on Paris Avenue carried streetcars and interurbans. The building on the corner of Market Street (now U.S. 150) was constructed in 1907 by J.W. Ratcliffe. It housed Gropp Hardware from 1954 to 1991, and was razed in 1992.

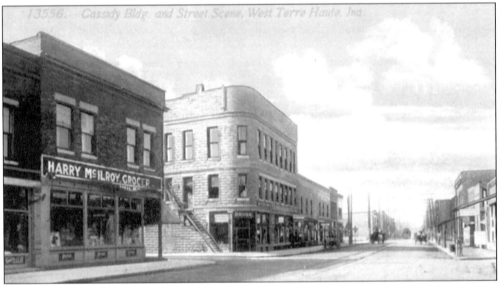

CASSIDY (SIC) BUILDING. AND STREET SCENE, WEST TERRE HAUTE. The buildings are located on Paris Avenue at the corner of McIlroy Avenue. Harry McIlroy was one of eight grocers in West Terre Haute in 1912. The three-story Cassaday Building housed the drug store of Burton Cassaday, who was appointed postmaster in June 1914. This building has been razed. Discount Muffler now occupies the McIlroy Building.

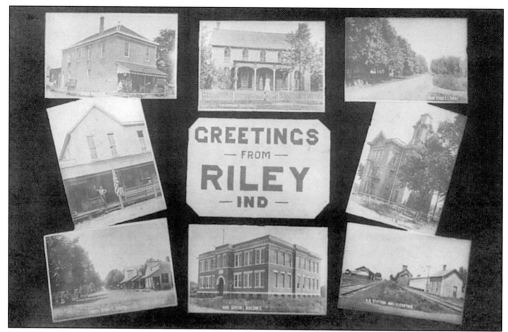

GREETINGS FROM RILEY. Views shown on this 1911 card, clockwise from the top left, include: The Odd Fellows (I.O.O.F.) Lodge building, the Telephone Exchange, Main Street east, the Masonic Redmen building, the railroad station and elevator, the high school building, Canal Street south, and the post office. The community of Riley is located southeast of Terre Haute at the junction of Indiana Roads 46 and 159.

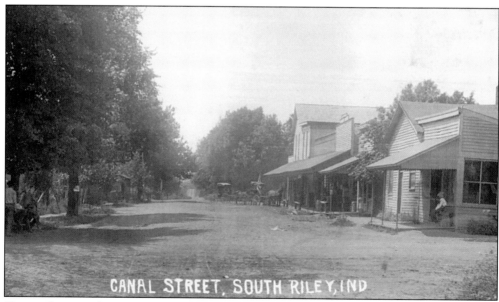

CANAL STREET, SOUTH RILEY. In 1836, Nathaniel Donham platted the village of Lockport, located by the Wabash & Erie Canal locks. The name was changed to Riley when the post office was established in 1840, because another city carried the name of Lockport. The street scene appears on a card postmarked 1912.

Three

BUSINESS AND INDUSTRY

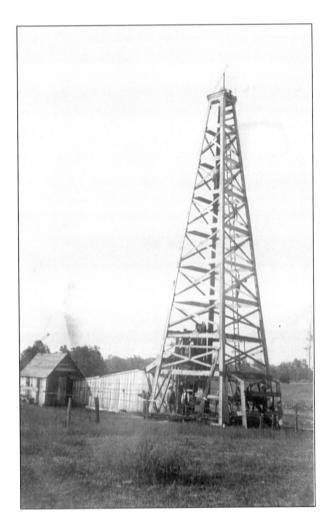

THE ORIGINAL VI-CLAY NO. 1, RILEY. The Vi-Clay Oil Company was organized by local residents. In 1906, a test bore was put down on the Joslin property in Riley Township, 2 miles southeast of the community of Riley. The 1,618-foot-deep well, shown on this card postmarked 1908, produced 132 barrels of oil the first day and caused a rush of oilmen into the area.

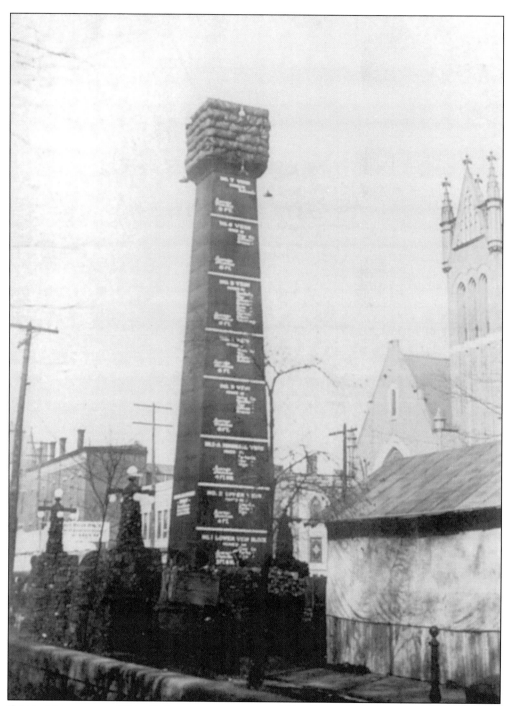

COAL MONUMENT. This 40-foot monument on Ohio Street, built by the Coal Operators Association, and a 60-foot ear of corn on Cherry Street were part of Terre Haute's Great Industrial Corn and Coal Show. The Booster Club sponsored this October 28 to November 2 event in 1912 to call public attention to the area's great natural resources. Note the bell tower of the First Congregational Church on the right.

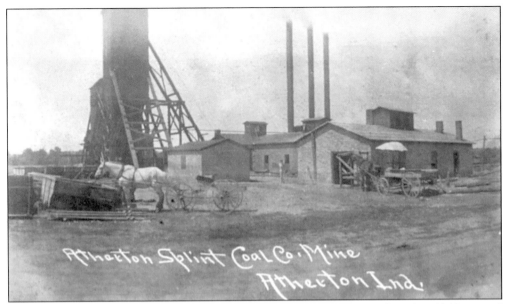

ATHERTON SPLINT COAL CO. MINE. The mine, shown on this postcard used in 1908, opened in 1903 along the Evansville, Terre Haute & Chicago Railroad (later the Chicago & Eastern Illinois Railroad). The mine was located south of Atherton, a small community on the northern edge of Vigo County. Housing was provided for employees and their families. The mine ceased operations in 1914.

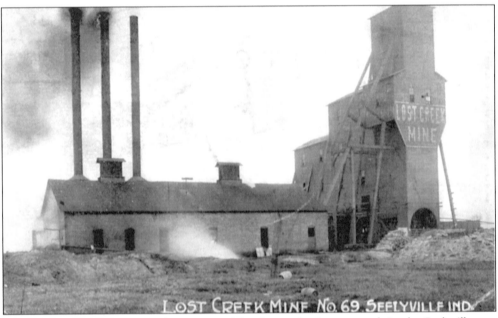

LOST CREEK MINE NO. 69, SEELYVILLE. The first coal mine was sunk in the Seelyville area in 1864 by Chauncey Rose and William Riley McKeen. Seventeen mines were located within a 3-mile radius of the town by 1906. One of these was the Lost Creek Mine, pictured on this card used in 1913. The handwritten note says the mine employed 400 and that the tipple was 96 feet tall.

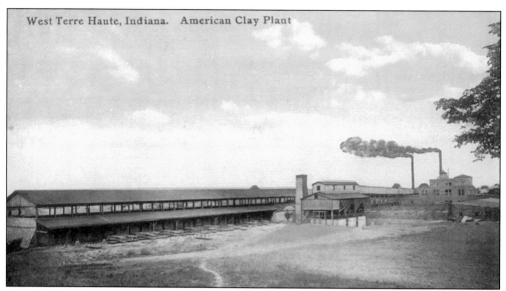

West Terre Haute, Indiana. American Clay Plant

WEST TERRE HAUTE, AMERICAN CLAY PLANT. This plant was said to be "the finest of its kind in the state" in 1912 for making drain, fireproofing, and roof tiles, and hollow blocks for smokestacks. It was located on a 10-acre tract with clay pits southwest of West Terre Haute, the area richest in clay and shale in Vigo County. Years later, the plant was used for growing mushrooms.

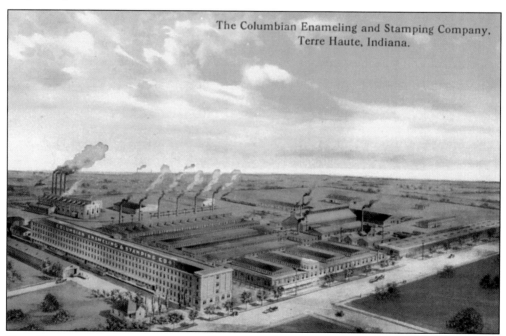

The Columbian Enameling and Stamping Company,
Terre Haute, Indiana.

THE COLUMBIAN ENAMELING AND STAMPING COMPANY. The company began operations in 1902 on a 15-acre site located on Beech Street between North Fifteen and One Half and Nineteenth Streets. By 1920, it was employing 1,200 workers to produce enameled steel household and hospital wares. The company became part of General Housewares Corp. in 1968, which in turn sold the granite ware business in 1998 to Columbian Home Products LLC.

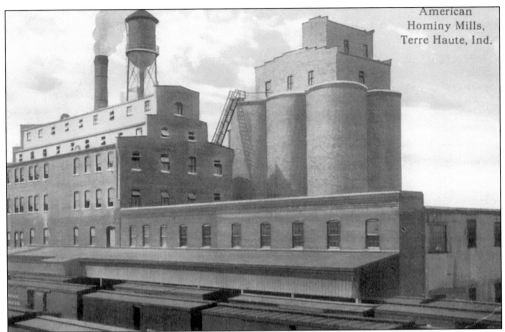

AMERICAN HOMINY MILLS. The hominy mills, owned by Theodore Hudnut and his son Benjamin, produced corn products such as grits, hominy, flour, and cooking oil under the brand name "Mazoil." Six of the mills were sold to the American Hominy Company in 1902. The Terre Haute Mill, shown on this card, was located on the northwest corner of Water and Chestnut Streets. The retail store was at 113 Poplar Street.

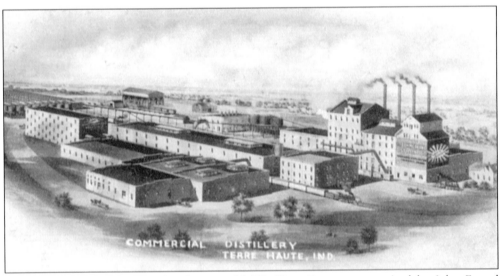

COMMERCIAL DISTILLERY. The Commercial Distilling Company, organized by John E. and Thomas Beggs early in the twentieth century, was located on the southwest corner of Prairieton Avenue and Demorest Street. Producing alcohol, spirits, gin, and whiskey, the plant soon consumed 2,000 carloads of coal and a million and a half bushels of corn each year. It was described as the largest distillery in the world.

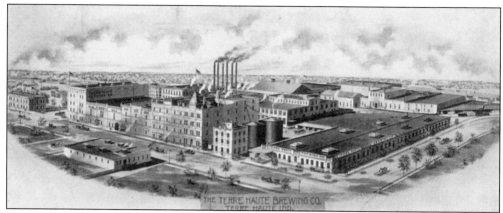

THE TERRE HAUTE BREWING CO. Anton Mayer established a brewery in 1869, the forerunner of the Terre Haute Brewing Company. Purchased by Crawford Fairbanks in 1889, the company was incorporated as the Terre Haute Brewing Co. and occupied the block at the southeast corner of Ninth and Poplar Streets. Acquired by Oscar Baur in 1933, the brewery was in production until 1958.

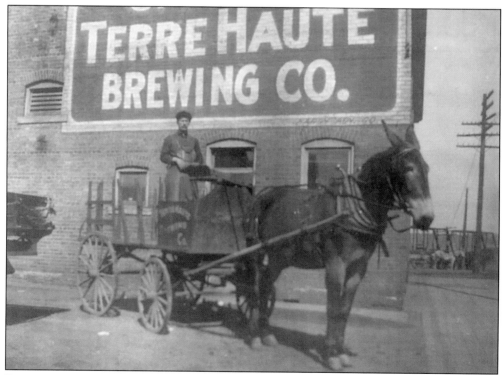

BEER WAGON. This mule-drawn wagon stood in front of the Terre Haute Brewing Company office building. At one time, the brewery was the seventh largest in the world and the largest in Indiana. The nationally known "Champagne Velvet" name was registered in 1902. From the onset of state prohibition on April 2, 1918, until 1933, the brewery was limited to production of non-alcoholic beverages.

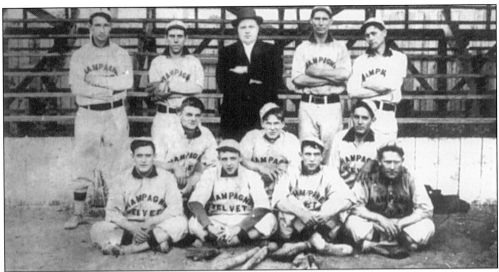

1908—CHAMPAGNE VELVET BASEBALL CHAMPIONS. This team won the Terre Haute city championship played at Seelyville on August 23, 1908. Max Carnarius (Carey), the only native-born Terre Hautean enshrined in the Baseball Hall of Fame at Cooperstown, New York, is at the left end of the middle row. Baseball enthusiast Paul C. Frisz published this card in 1961.

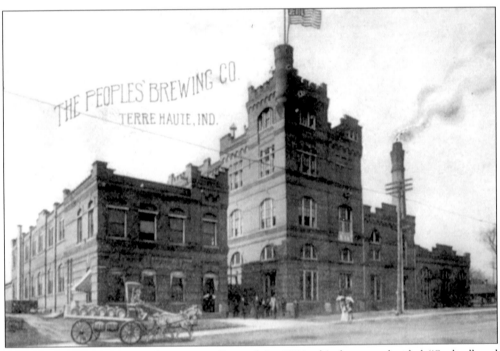

THE PEOPLES' BREWING COMPANY. Opened in 1906, this brewery bottled "Spalter" and "Celtic" beers in its plant at First and Wilson Streets. A 1912 advertisement with this photo reads: "The beer that speaks for itself. . . freedom from adulteration. . . purity of water used in manufacture. Commended by the highest health authorities for family use or the club." The brewery introduced "Celto" cereal beverage in 1918 as an alternative to Prohibition, but by 1924 had become Peoples' Ice and Storage Company.

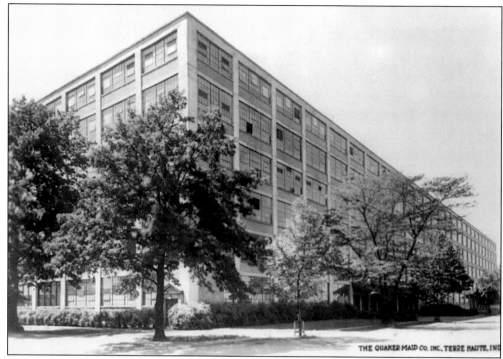

THE QUAKER MAID CO., INC. The plant opened in 1930 at 300 North Fruitridge Avenue. A large variety of Ann Page, Iona, and Sultana brands of foods were produced there for nationwide distribution by the Great Atlantic & Pacific Tea Co. (A&P Company). Additions to the building were constructed in 1940 and 1953. The plant closed in 1979. The building is now the home of Jadcore, Inc.

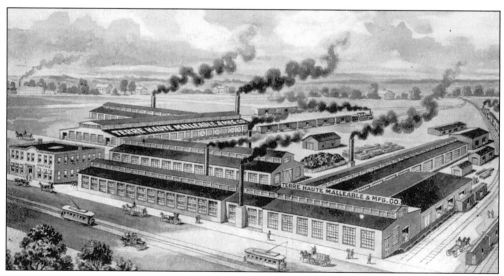

TERRE HAUTE MALLEABLE & MFG. CO. Albert W. Wagner and Henry S. Wanner founded this company in 1906 to produce malleable iron castings. The 35-acre plant was located on North Nineteenth Street, extending north to Maple Avenue. The plant closed in 1985.

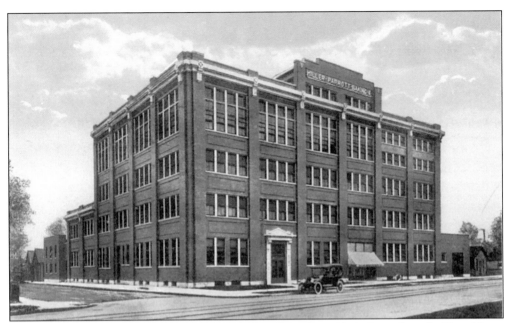

MILLER–PARROTT BAKING COMPANY. Miller-Parrott supplied baked goods to the Terre Haute area from 1880 to 1958. First located in Dowling Hall, the company constructed this building at 1450 Wabash Avenue in 1914 for its plant. Later occupants include Eastern Express Inc., American Tredex, and Patterson Equipment. The building is now the home of the Light House Mission, a 1990 gift of Herbert Patterson.

MILKS EMULSION. James E. Milks developed this petroleum-based remedy for the lungs, stomach, and bowels. By 1904, it enjoyed distribution and the sale of 1,500 packages each month in Terre Haute. The plant was first located at 213 Ohio Street. By 1922, the year this card was postmarked, the location had changed to 507 North Thirteen and One Half Street.

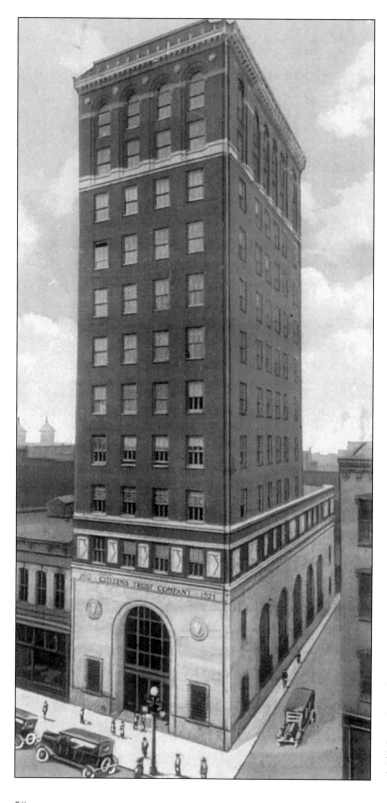

CITIZENS TRUST COMPANY BUILDING. The Citizens Trust Company was first organized in 1913 and located at 612–614 Wabash Avenue. Outgrowing this structure, they constructed a new limestone and red brick building at a cost of approximately $318,000. Now known as the Sycamore Building, "Terre Haute's tallest skyscraper" opened to rave reviews on November 21, 1921. The 12-story building at 19–21 South Sixth Street was described as "the last word in modern office building architecture— the new skyscraper will be the pride of Terre Haute." In 1928, Citizens became the National Bank & Trust Company. Sunset Harbor Inc. purchased the Sycamore Building in 1964 from the estate of Emma Herber, widow of pharmacist Conrad Herber. Listed on the National Register of Historic Places, it remains the tallest commercial building between Indianapolis and St. Louis. The Woodburn building (c. 1859), at the left, continues to be occupied by Woodburn Graphics.

OFFICE AND SALESROOMS OF LEVIN BROTHERS, SIXTH AND OHIO STREETS.
The Terre Haute Savings Bank, incorporated in 1869, constructed the building shown here in 1911. Levin Brothers., a dry goods wholesale firm, occupied the top five floors until they discontinued business in 1968. A decision was made to remove these floors in 1972. The Terre Haute Savings Bank continues to occupy the building for its main office.

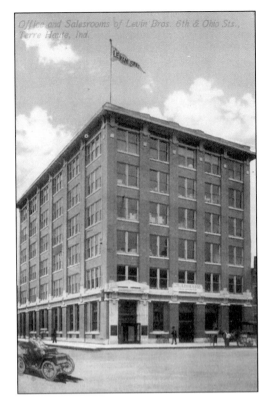

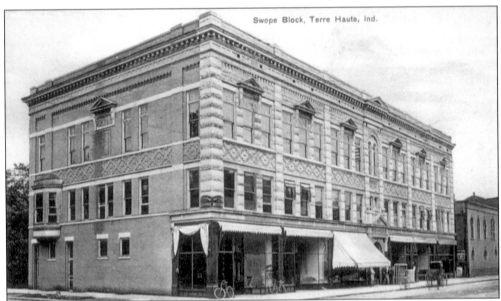

SWOPE BLOCK. Sheldon Swope (1843–1929) built this commercial building on the northwest corner of Seventh and Ohio Streets in 1902. The Wabash Business College occupied the third floor in 1907, the postmark date on this card. Sheldon Swope provided for the creation of the Swope Art Gallery in his will, and it opened on the second floor in 1942. It was renamed the Sheldon Swope Art Museum in 1988.

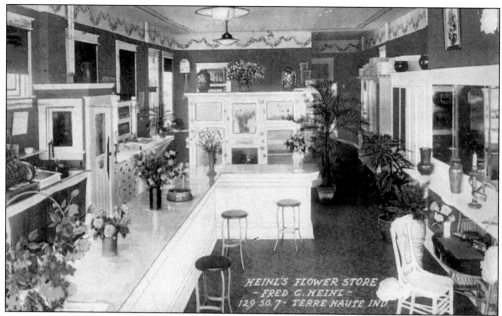

HEINL'S FLOWER STORE. Fred G. Heinl was the son of John G. Heinl, who had opened one of the first floral stores in the city in 1863. The two men went into business together in 1894, and later moved their store into a new two-story brick building at 127 South Seventh Street. Heinl's remains in business at this location.

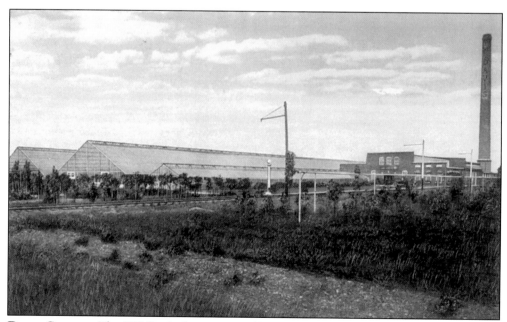

DAVIS GARDEN. The J.W. Davis Company established this business with three greenhouses off South Seventh Street in 1914. O. Keith Owen Sr. became president in 1938. By 1962, the firm had expanded to 60 acres with 35 acres under glass—the largest greenhouses under glass with a central heating plant in the world. The business closed in 1974. Westminster Village retirement community now occupies the site.

TERRE HAUTE PURE MILK AND ICE CREAM CO. The company, organized in 1902 by George C. Foulkes, John S. Cox, and John G. Dobbs, built a plant on North Fifth Street between Sycamore Street and the Vandalia Railroad. Advertisements emphasized "milk from tuberculin-tested herds clarified and pasteurized according to sanitary regulations." The site is now part of the Indiana State University campus.

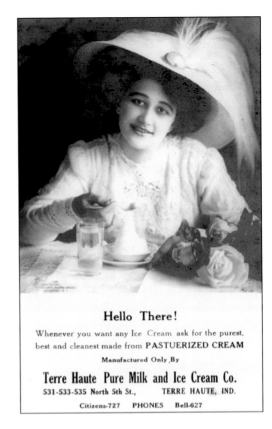

Hello There!

Whenever you want any Ice Cream ask for the purest, best and cleanest made from PASTUERIZED CREAM

Manufactured Only By

Terre Haute Pure Milk and Ice Cream Co.
531-533-535 North 5th St., TERRE HAUTE, IND.

Citizens-727 PHONES Bell-627

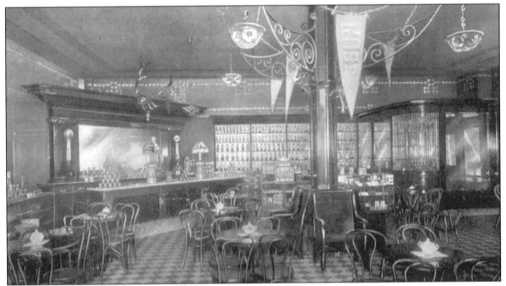

THE ROSE PHARMACY. This well-advertised Averitt-Dorsey Drug Co. pharmacy was located at 676 Cherry Street on the first floor of the Rose Dispensary Building. A 1910 advertisement reads, "the home of pure drugs. Open all night. We call for and deliver prescriptions at all hours of the day and night." Only Squibb Chemicals and Pharmaceuticals were dispensed.

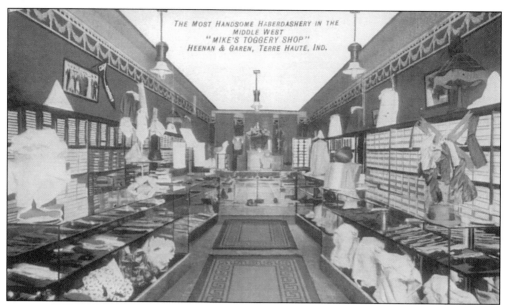

MIKE'S TOGGERY SHOP. J. Mike Heenan and Charles E. Garen were the proprietors of this shop located at 715 Wabash Avenue. They claimed their shop was "the most handsome haberdashery in the middle west." A 1910 advertisement described their operation as "hatters, tailors, shirt builders, and men's furnishings."

HOME OF THE HUNTER LAUNDERING & DYEING COMPANY. This building was located on the northeast corner of Sixth and Cherry Streets, now the site of the Indiana State University Technology Building. In 1900, the company had agencies in 135 towns within a 150-mile radius of Terre Haute. Two decades earlier, James Hunter had started his laundry with two tubs in the rear of his store on Wabash Avenue.

HERZ BUILDING.
The Herz Building was constructed in 1906–07 by William Riley McKeen to house the department store of Adolph Herz. Designed by W. Homer Floyd and located at 646–652 Wabash Avenue, the five-story enameled brick structure featured three elevators and a mezzanine. The Pennsylvania Railroad ticket and freight office, shown on the east side of the store, was the Herz Annex by 1915.

Herz (1843–1917), a leading merchant and civic leader, had been in business in Terre Haute since 1869. Downtown stores closed in his memory on the day of his funeral. His son, Milton Herz, succeeded him as manager. The business was sold to Alden's Department Store chain in 1946 and became the Alden-Herz store. The Alden's, J.C. Penney, and Sears Roebuck buildings were razed in the spring of 1971.

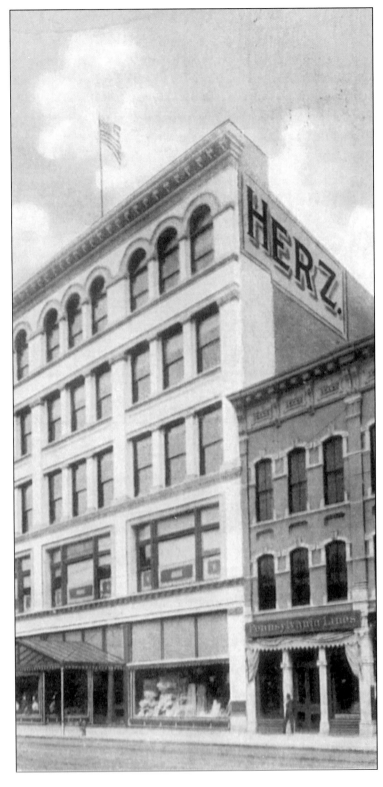

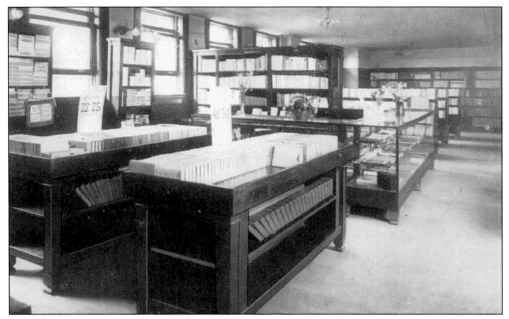

BOOK DEPARTMENT, A. HERZ STORE. "An entirely new line of local postal cards—1 cent each" was available in the book department, at the rear of the first floor according to a 1914 advertisement. "All telephone and telegraph poles that usually mar the pictures" had been eliminated. Printed in duotone effect, views of the store departments were included in the series.

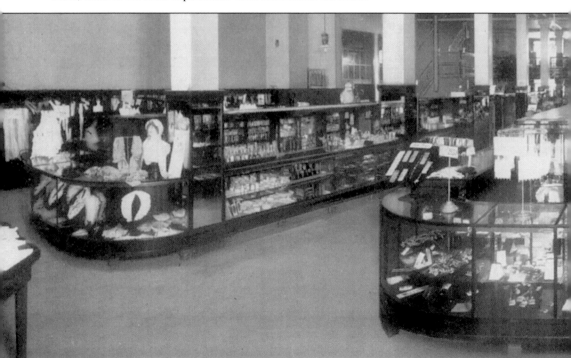

MAIN FLOOR, A. HERZ STORE. A full line of department store goods, including women's and children's apparel, notions, home furnishings, leather goods, and books, was carried. The first

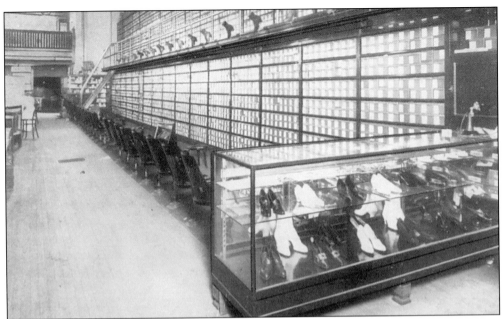

SHOE DEPARTMENT, A. HERZ STORE. The shoe department was one of many well-stocked departments at the Herz Store, where 250 persons were employed. Wide aisles and a pneumatic tube cash system were added conveniences for customers and employees.

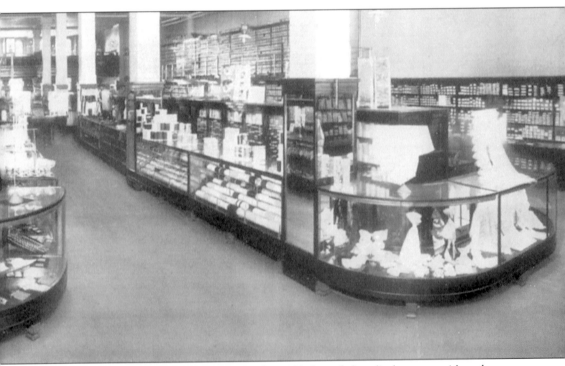

and second floors were equipped with more than 600 feet of glass display cases with mahogany countertops. Lunch was served in the Herz Tea Room.

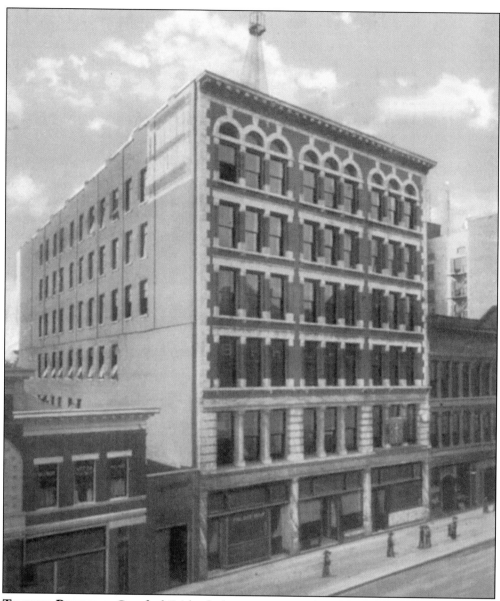

TRIBUNE BUILDING. Crawford Fairbanks began preparing for the construction of the Tribune Building in 1911, when he asked the occupants located on the site to vacate. These included the Smith & Doyle and C.F. Schmidt Saloons, the Nickeldom Theater, and DeArmott Bros. Cigar Store. The new six-story Chicago-style commercial building, 721–725 Wabash Avenue, opened in 1912 to house the Tribune newspaper, which Fairbanks had purchased in 1908. The Lease Brothers Billiard Hall occupied the third floor.

In 1931, the Tribune and Star came under single ownership, as the Tribune-Star Co. A 1978–79 construction project changed the Grand Theater, partially shown as the Liberty on the left, into a facility to house the newspaper presses. Two separate newspapers were published until 1983, when they merged into a single morning newspaper, the *Tribune-Star.* The newspaper, owned by Thomson Newspapers, moved to the new Tribune-Star Building at 222 South Seventh Street in 1997. The former Tribune Building now stands vacant.

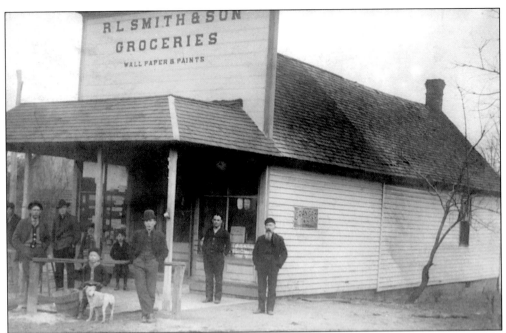

R.L. SMITH & SON GROCERIES, PRAIRIETON. Owner Robert L. Smith and his son, George, appear at the right of this card, *c.* 1909. The small boy is Hugh Smith, the youngest of Robert's 11 children, who later became part of what would become a three-generation business, which also sold wallpaper and paints. The store was located on the east side of the main street (now Indiana 63) in Prairieton.

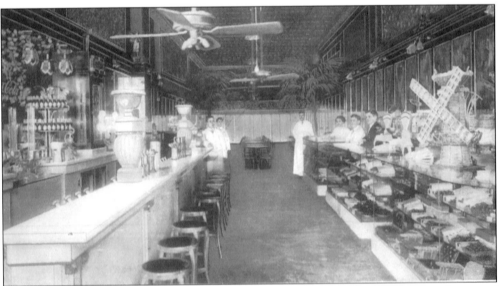

THE GREEK CANDY KITCHEN. By 1900, the Georgopoulos name was part of the confectioners' trade in Terre Haute. James, proprietor of the store advertised on this card, first worked as a clerk at the Papdakos & Georgopoulos shop, 826 Wabash Avenue. By 1907, he had opened his own store at 676 Wabash Avenue, next door to Conrad Herber's Oak Hall Pharmacy.

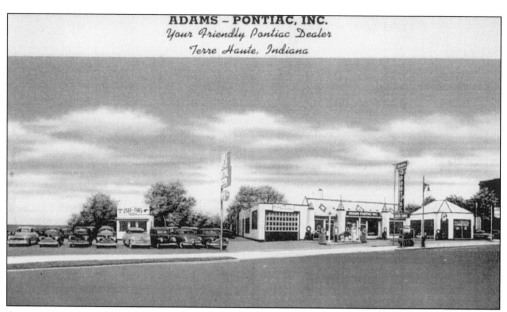

ADAMS-PONTIAC, INC., "YOUR FRIENDLY PONTIAC DEALER." Adams-Pontiac Inc., located at 1430 Wabash Avenue, became the authorized Pontiac dealer in Terre Haute in 1943. This early view shows the building before it was remodeled. Founder Harry Adams, who also headed Motor Freight Corporation, was succeeded by his son Ronald Adams. The business remained at this location through 1981. The site is now occupied by Tempo Furniture.

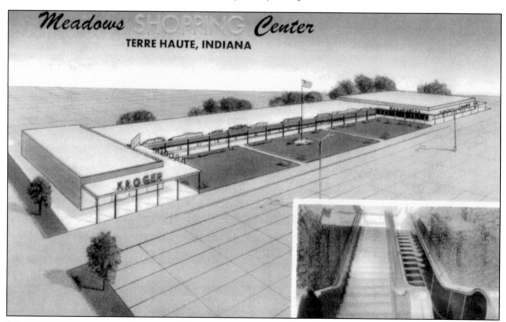

MEADOWS SHOPPING CENTER. The center was completed in 1956, with parking available for 1,500 vehicles. A Kroger supermarket and a large Woolworth store were among the 22 original tenants. When a Vigo County Public Library branch opened there two years later, it was the first library to be located in a shopping center in the state of Indiana. The center became The Meadows after its 1982–83 renovation.

Four

PARKS AND ENTERTAINMENT

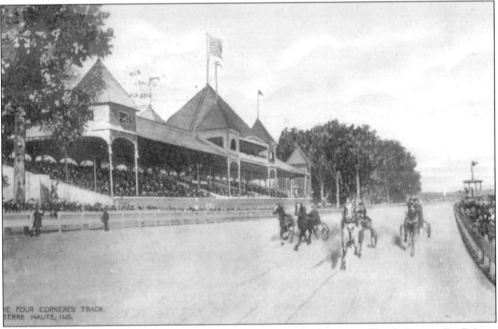

FOUR CORNERED TRACK. William Riley McKeen gave the 54 acres of land, George R. Grimes drew the design, and the Trotting Association paid $5,695 for the construction of this track in 1886, at the northeast corner of Brown and Wabash Avenues. Racing history was made there with records set by Axtel, Mascot, and Nancy Hanks. A half-mile track in use during the Indiana State Fair held in Terre Haute in 1867 formerly occupied the grounds. Memorial Stadium now is located on the site.

ENTRANCE COLLETT PARK. The 21-acre park, shown on this card used in 1907, was established on land given to the city in 1883 by Josephus Collett, a successful businessman. It is bounded by Collett Avenue (north), Ninth Street (east), Maple Avenue (south), and Seventh Street (west). The park's 100th birthday was noted with ceremonies on July 16, 1983.

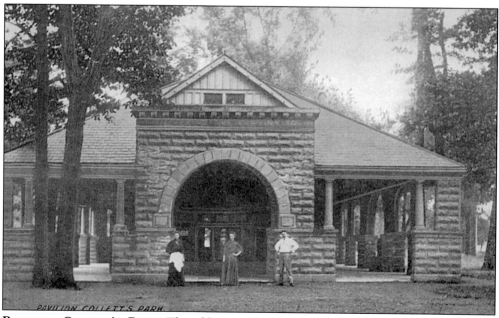

PAVILION, COLLETT'S PARK. The oldest structure in the city's oldest park is the pavilion, designed by local architect J. Merrill Sherman and shown here. The nomination form for the 1981 listing on the National Register of Historic Places, written by Dr. William B. Pickett, describes the park as "a popular location for Sunday afternoon horse-and-buggy rides, band concerts, and picnics near the turn of the century."

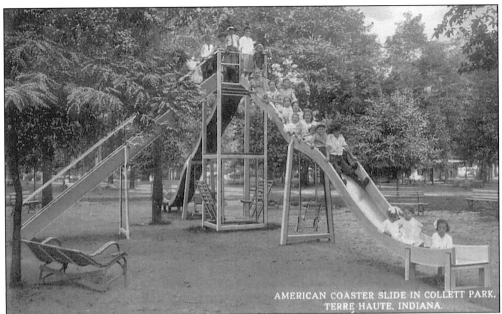

AMERICAN COASTER SLIDE IN COLLETT PARK. The playground equipment, pictured on this card used in 1913, was manufactured by the American Playground Device and Swing Co., located on the east side of Eighteenth Street, one block north of Maple Avenue. W.H. Freeman, L.D. Townsend, Otto Fries, and George W. Krietenstein were the officers of the company.

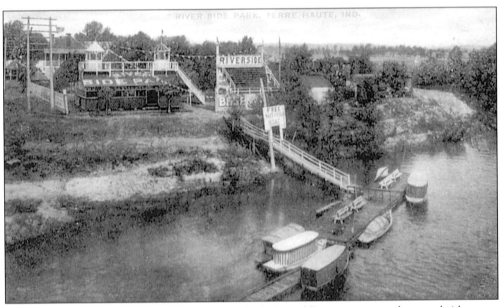

RIVER SIDE PARK. A 1907 advertisement invited the public to come see the new bridge over the Wabash River and then drop in at Riverside Park on the west bank. The features of this summer and winter garden included "a first-class café and bar and a lunch stand always open for boatmen, pearl hunters, shell men, fishermen, and pleasure seekers." Charles Denning and Frank Clark were the proprietors.

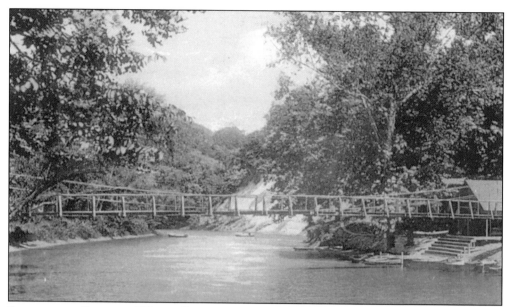

SUSPENSION BRIDGE, 150-FT. SPAN, FOREST PARK. From 1903 through the 1920s, the 365-acre park was an amusement attraction. A Civilian Conservation Corps (CCC) camp was based there during the Great Depression. Purchased by Hulman & Company in 1939, the park has been managed by Terre Haute First National Bank since the 1970s. The suspension bridge over Otter Creek is no longer there.

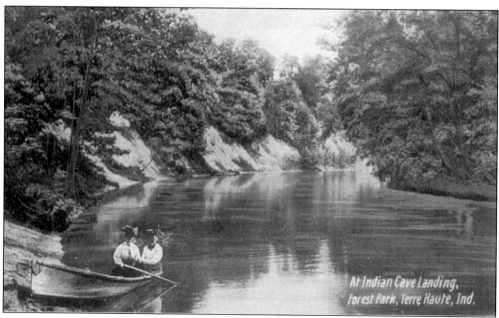

INDIAN CAVE LANDING, FOREST PARK. A 1907 advertisement reads: "Forest Park is the ideal spot for picnics. Its beauties are just as Nature planned. . . It has more acreage than the combined area of all the parks of any city in the state. Otter Creek flows for two miles within its limits, amid scenery that has few rivals for wildness, beauty, and grandeur. Admission 5 cents. Carriages free."

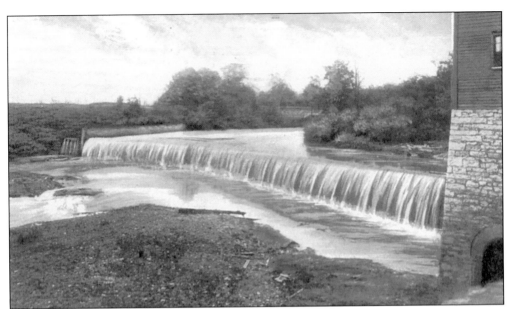

FOREST PARK DAM. The Markle Mill appears on the right side of the dam on this card, postmarked 1914. Constructed of white oak and fastened with wooden pegs, the surface later was covered with concrete. For a time Charles D. Hansel, mill operator from 1911 to 1938, used the "Forest Park Mill" name for his business.

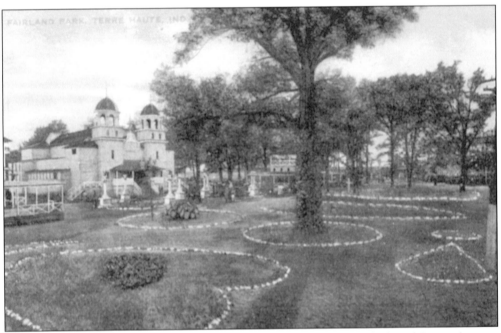

FAIRLAND PARK. Formerly the Lake View Park, this attraction near Wabash and Brown Avenues was known as Fairland Park by 1908. An advertisement in the *Tribune* invited the public to "take the East Wabash Avenue streetcar to Terre Haute's popular summer amusement place." Concerts by the Ringgold Band, free moving pictures, and animal acts were among the attractions.

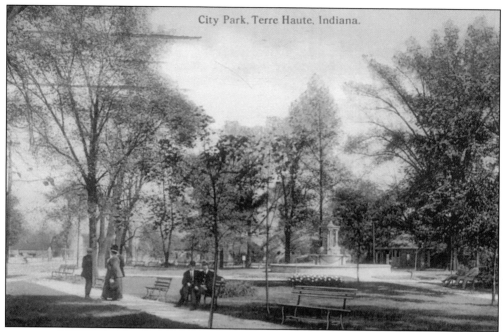

City Park, Terre Haute, Indiana.

CITY PARK. This peaceful afternoon scene was photographed at City Park during the early years of the twentieth century. Located at Fourteenth Street and Wabash Avenue, it became known as Steeg Park in honor of Henry C. Steeg, who was elected mayor in 1898. It now carries the name of Curtis Gilbert, postmaster at Fort Harrison in 1817–18 and first clerk of Vigo County, whose country home was once located on this site.

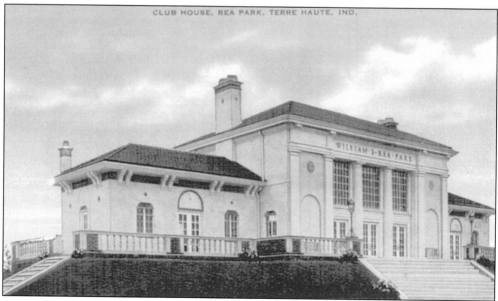

CLUB HOUSE, REA PARK, TERRE HAUTE, IND.

CLUB HOUSE, REA PARK. The land for Rea Park municipal golf course was purchased with funds from a trust established by William S. Rea, a wholesale grocer. The facility opened in 1925 at Seventh Street and Davis Drive. Funds for the clubhouse, constructed in 1925, were given by Geraldine Knecht Rea in memory of her husband.

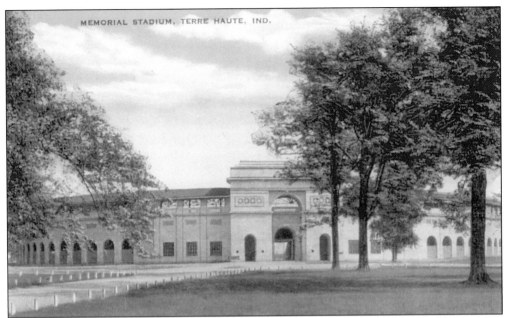

MEMORIAL STADIUM, TERRE HAUTE, IND.

MEMORIAL STADIUM. The Terre Haute Memorial Stadium was built in 1924, in memory of the "boys who served in the World War." Located on the site of the former fairgrounds on East Wabash Avenue, it was home to the Terre Haute professional baseball teams, high school and college games, and county fairs. The facility was leased to Indiana State University in 1966.

ONE OF THE "WIENER ROASTERS" IN DEMING PARK. The city secured 155 acres from Demas Deming Jr. for $155,000 in 1921. Rose Polytechnic Institute was to receive $100,000, and $55,000 was to be used to extend Ohio Boulevard to the park. By the 1940s, 23 picnic spots with park ovens were available for use. Each oven was given a Native American name such as Ouabache and Ute.

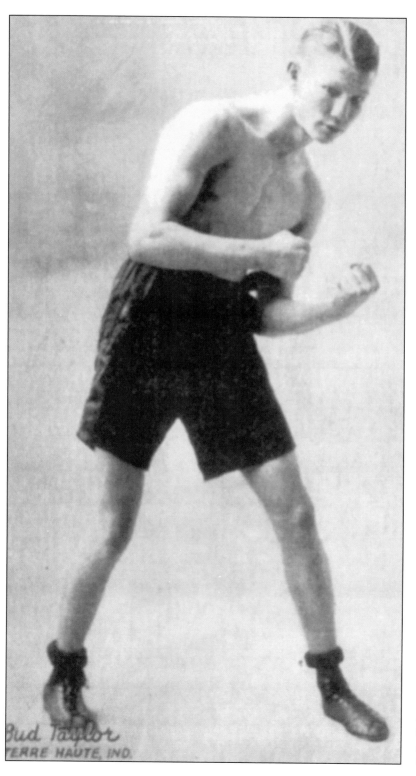

Bud Taylor
TERRE HAUTE, IND.

BUD TAYLOR. Charles "Bud" Taylor (1903–1962) was known as the "Blonde Terror of Terre Haute" in the boxing world. His record through 1928 appears on the back of this card: matches 119, knockouts 27, won from 34, draw 3, no decision 47, knocked out by 2, lost 6. He held the world bantamweight championship in 1927–28. Taylor is in the Helms Foundation Hall of Fame and the *Ring Magazine* Hall of Fame.

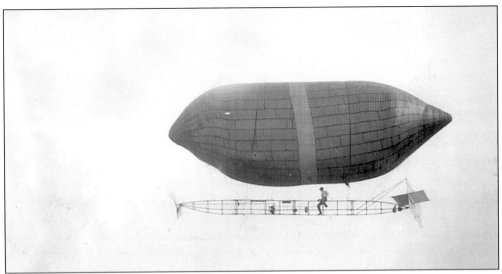

EXHIBITION FLIGHT OF THE COMET TAKEN FROM TRUST BUILDING. Horace Wild piloted the airship "Comet" past the Trust Building and around the courthouse tower on August 18, 1909, as part of the Vigo County Fair. Owned by George E. Yager of Nebraska, the airship was 45 feet long and 16 feet in diameter, with a varnished silk covering. The spruce frame was to carry a small gasoline engine, and the pilot was suspended by fish line. Hydrogen for lift was generated chemically at the fairgrounds.

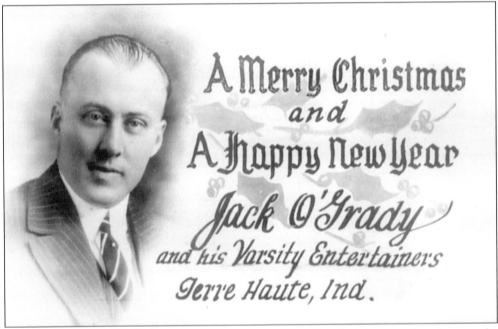

JACK O'GRADY AND HIS VARSITY ENTERTAINERS. This holiday greeting features the countenance of Jack O'Grady (1889–1971). A popular musician, skilled on the drums, piano, and xylophone, O'Grady and his Varsity Entertainers played throughout the Midwest and then served as the house orchestra at the Grand Theater from 1926 to 1928. He also served in the Indiana legislature from 1937 to 1955.

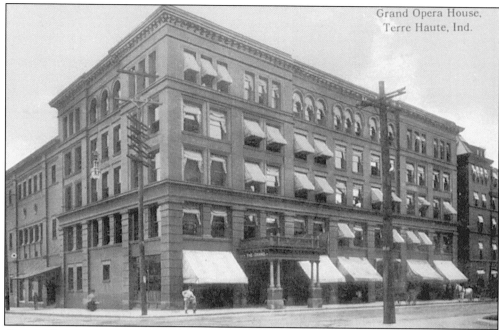

Grand Opera House, Terre Haute, Ind.

GRAND OPERA HOUSE. After a fire destroyed the Naylor Opera House, the Grand Opera House was built on the southeast corner of Seventh and Cherry Streets by contractor August Fromme. Theodore W. Barhydt was the manager on opening night, November 2, 1897. The theater was adapted to movies as the Grand Theater in the 1930s and razed in 1960 to make way for a Terre Haute House parking lot.

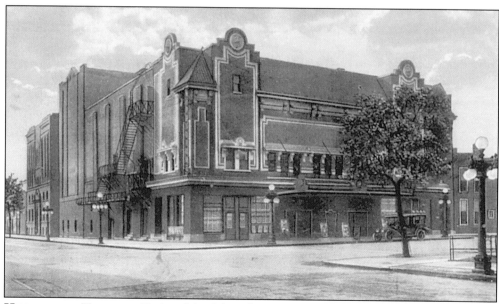

HIPPODROME THEATER. Designed by John Eberson and built by Theodore W. Barhydt, this vaudeville house seating 1,000 patrons opened in 1915 on the southwest corner of Eighth and Ohio Streets. By 1948, it was a movie house—The Wabash Theater. The building was purchased in 1955 by the Scottish Rite, Valley of Terre Haute, for a permanent cathedral.

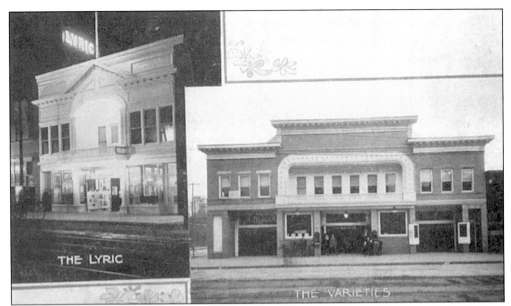

THE LYRIC

THE VARIETIES

THE LYRIC AND THE VARIETIES. Theodore W. Barhydt and Jack Hoeffler opened the Lyric at 720 Wabash Avenue in 1905 as a 10¢-vaudeville house playing four acts and a single reel movie. The Varieties vaudeville theater was built across the street in 1907. Later, the Lyric became the Orpheum; a new Orpheum Theater was built on the site in 1919.

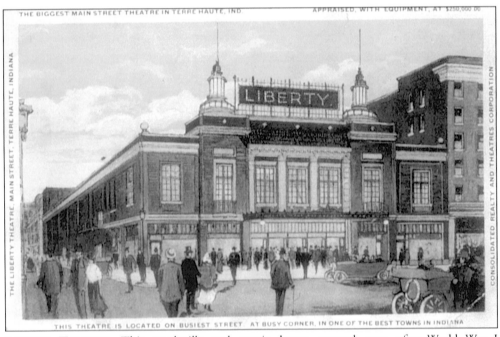

THE BIGGEST MAIN STREET THEATRE IN TERRE HAUTE, IND. APPRAISED, WITH EQUIPMENT, AT $250,000.00

THE LIBERTY THEATRE, MAIN STREET, TERRE HAUTE, INDIANA

CONSOLIDATED REALTY AND THEATRES CORPORATION

THIS THEATRE IS LOCATED ON BUSIEST STREET, AT BUSY CORNER, IN ONE OF THE BEST TOWNS IN INDIANA

LIBERTY THEATER. This vaudeville and movie house opened soon after World War I on the site of the former Varieties Theater on the southwest corner of Eighth Street and Wabash Avenue. The Liberty Theater later became the Grand Theater; the structure now houses the Tribune-Star presses.

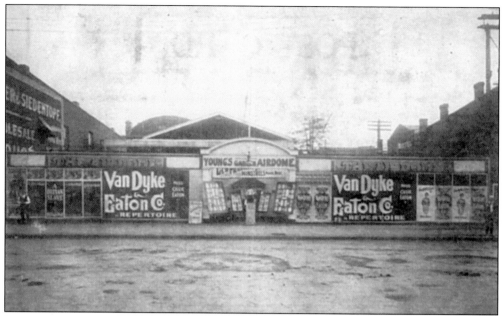

YOUNG'S GARDEN AIRDOME. Bearing a 1910 postmark, this card shows Young's Garden Airdome, an open-air theater at 321 Ohio Street, owned and operated by Samuel Young Jr. The VanDyke and Eaton Company Repertoire, featuring Miss Eaton, was showing at the time this photo was taken. Note the rounded roof of city hall in the background.

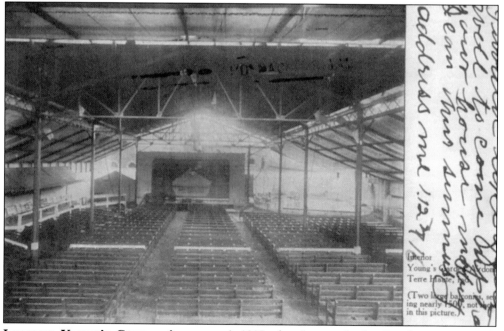

INTERIOR, YOUNG'S GARDEN AIRDOME. A 1908 advertisement in the *Saturday Spectator* reads "new steel roof—water-proof. . . 1,000 seats, 10 cents each." The structure was later transformed into offices and retail stores. It now houses the Modesitt, Bough & Kelly law offices.

Five

HOTELS

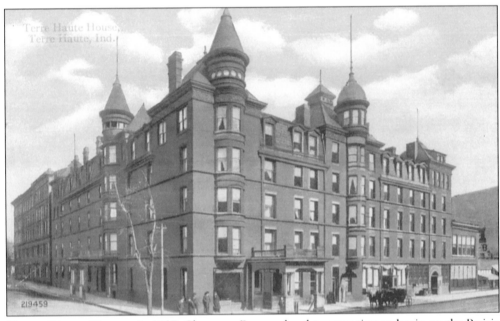

TERRE HAUTE HOUSE. In 1837, Chauncey Rose ordered construction to begin on the Prairie House on the National Road about six blocks east of the Wabash River. The name was changed to the Terre Haute House and the building raised to four stories in 1855. The hotel was first in the world to have electric lights in all the rooms (1886) and the first to supply portable electric fans (1891). It was remodeled in 1892 and again in 1914. Work began to raze the structure on February 18, 1927, to make way for a new Terre Haute House.

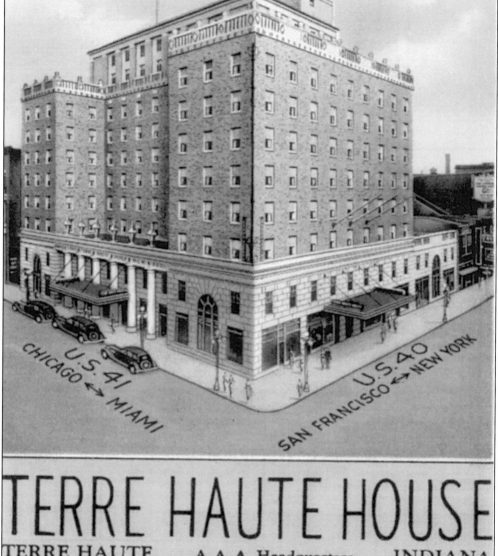

TERRE HAUTE HOUSE

TERRE HAUTE A.A.A. Headquarters INDIANA

At the Crossroads of the Nation

250 Rooms 250 Baths

Dining Rooms Rates $2.00 up Garage

TERRE HAUTE HOUSE. This site at Seventh Street and Wabash Avenue has been occupied by hotels since the Prairie House was constructed there in 1837. Work began on the hotel featured on this card in 1927 after the former Terre Haute House had been razed. A two-day celebration marked the opening in July of 1928. The size of the Marine Room was doubled in 1935, and the Mayflower Room opened in 1936. The Anton "Tony" Hulman family purchased the hotel in 1959. Business declined in the late 1960s, when the "crossroads" moved from Seventh and Wabash to U.S. 41 and Interstate 70 south of the city. The hotel closed to travelers in 1970. The last remaining business, World Wide Travel Service, moved away and the coffee shop closed in 1980. The building now stands vacant.

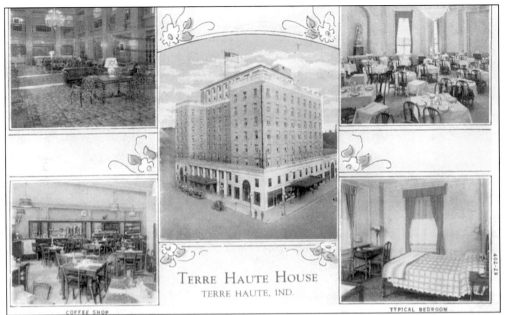

TERRE HAUTE HOUSE. Photos of the lobby, dining room, coffee shop, and a typical bedroom are included on this card used in 1931. The advertisement on the back reads "Terre Haute's new, leading fire-proof hotel. 250 rooms, each with a bath. At the intersection of the Dixie Highway and the Old National Trail 'On the Banks of the Wabash.' Rates $2.50 to $4.00. 100 rooms at $2.50."

THE NORTHERN HOTEL. On August 14, 1899, Albert Monninger and Charles J. Dressler opened their Northern Hotel, built by August Ohm. Renamed the Great Northern in 1907, it was located on the southwest corner of Seventh and Tippecanoe Streets, across from the Big Four railroad station. The building was razed in 1969, after the property became part of the Indiana State University campus.

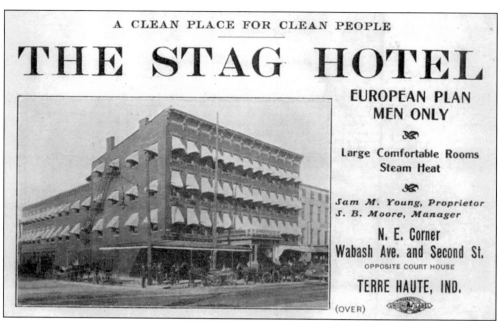

THE STAG HOTEL. The building on the northeast corner of Wabash Avenue and Second Street was remodeled in the 1870s to become the St. Clair House. It was remodeled again by Samuel M. Young Jr. in the 1890s for the Wabash Avenue Hotel and then renamed the Stag Hotel. For "men only," it was advertised as "a clean place for clean people."

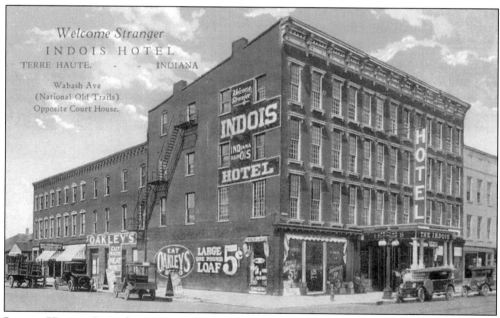

INDOIS HOTEL. Samuel M. Young Jr. remodeled the hotel at 204 Wabash Avenue, opposite the Vigo County Courthouse, in 1928, and the name was changed from the Stag to the Indois Hotel. Storefronts faced both Wabash Avenue and Second Street. Note the Oakley's store, part of the local Oakley grocery store chain. The building was razed in 1969.

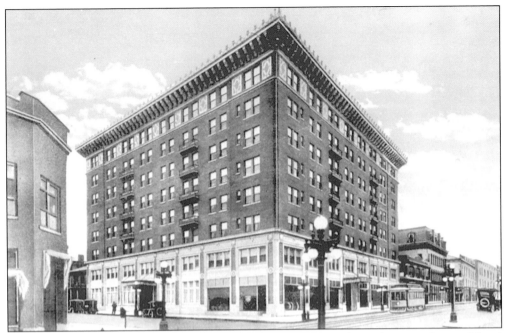

HOTEL DEMING. Demas Deming Jr. (1841–1922) constructed this eight-story fireproof hotel in 1913–14, on the southeast corner of Sixth and Cherry Streets. Purchased by Indiana State College in 1963, the building was used as a residence hall and later as a conference center. A 1978–79 renovation project transformed it into the Deming Center apartment complex for older persons.

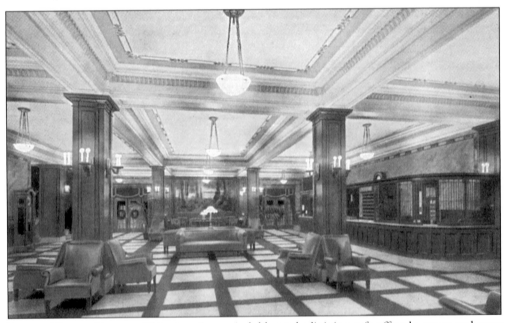

LOBBY, HOTEL DEMING. This attractive main lobby and adjoining cafe offered a warm welcome to guests arriving at the Hotel Deming. The eight floors included 250 "outside rooms," with baths and a spacious ballroom on the second floor.

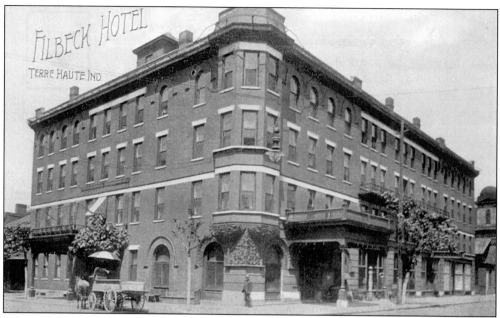

FILBECK HOTEL. The northeast corner of Fifth and Cherry Streets, now a part of the Indiana State University campus, was the site of the Pavilion, Johnson House, and Filbeck Hotels. Nick Filbeck replaced the "old" Filbeck with the Filbeck Hotel, pictured here, in the 1890s. The building was razed in 1961, to make way for the 500 Cherry Street Corporation parking lot.

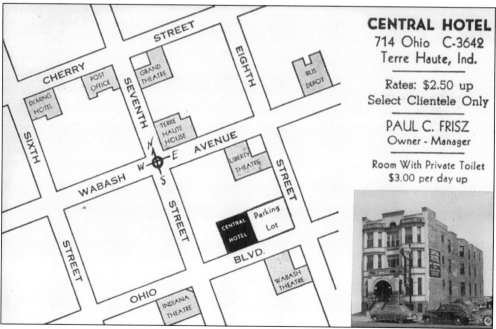

CENTRAL HOTEL. Paul Frisz purchased the Central Hotel at 714 Ohio Street in 1948. It was "home" to the Terre Haute Phillies baseball players when they were in the city. Frisz, an avid baseball supporter, used Room 1 of the hotel to display his collection of baseball memorabilia. He retired in 1968. Old National drive-through banking service now occupies the site.

78

Six

RELIGION

FIRST M.E. CHURCH. Described in 1900 as "the most costly and elegant Protestant church in the city," the First Methodist Episcopal Church was located on the northwest corner of Seventh and Poplar Streets. The cornerstone was laid in 1894, and the structure was built at a cost of $45,000. Dedication took place May 26, 1895. The building became known as the Methodist Temple in 1925, after a merger of the First and Centenary Methodist Churches. This agreement was dissolved in 1929. The congregation moved to the new United Methodist Temple building at 5301 South U.S. Highway 41 in 1969. The 1895 structure was razed soon after. The main building and grounds of the Vigo County Public Library now occupy the site.

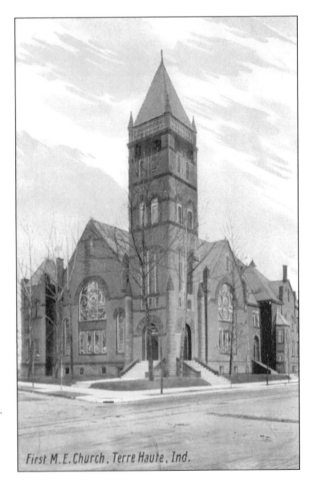

First M.E. Church, Terre Haute, Ind.

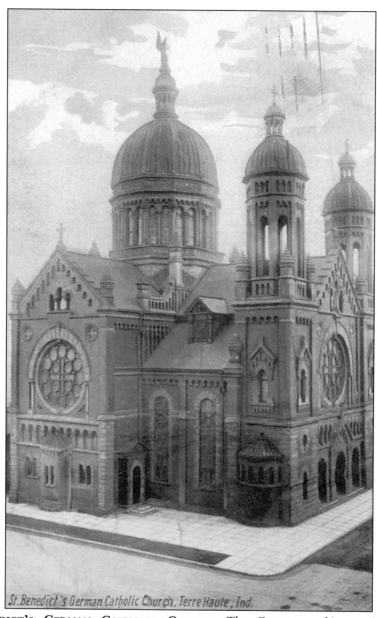

St. Benedict's German Catholic Church, Terre Haute, Ind.

ST. BENEDICT'S GERMAN CATHOLIC CHURCH. The German-speaking parishioners of St. Joseph's Church purchased land on South Ninth Street between Ohio and Walnut Streets as a site for their own church to face Ohio Street. The cornerstone for their original building was laid in 1864. With the growth of the congregation, a larger church was planned to better serve the parish. Adolph Druiding of Chicago was chosen as the architect. The original church was razed, and a new structure facing Ninth Street was built. Dedication of the new church, shown here, took place on June 18, 1899. A fire on July 30, 1930, destroyed the center dome and much of the interior. The rebuilt structure was dedicated December 13, 1931. The Immaculate Conception Catholic Church of Celina, Ohio, built in 1900–03, is modeled after St. Benedict's and still retains its full dome.

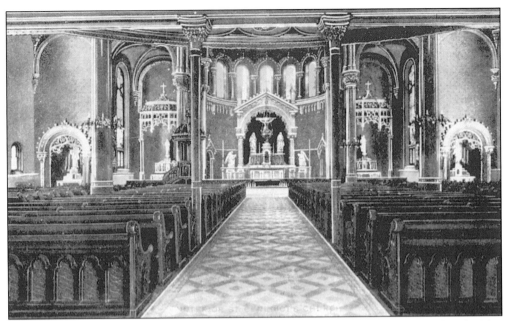

INTERIOR, ST. BENEDICT'S CHURCH. The interior of the new church was described in the *Terre Haute Express*: "Around the walls at equal intervals the 14 stations of the holy way of the cross are placed. The walls of the church are light buff in color with a wainscoting of white and clouded marble six feet high." These views were taken before the fire.

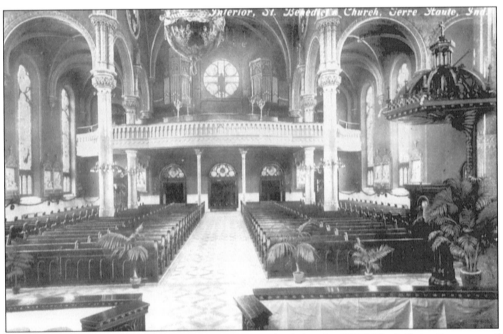

INTERIOR, ST. BENEDICT'S CHURCH. An organ, built by the W.W. Kimball & Company of Chicago, was installed above the vestibule of the church opposite the altar. Works of noted artists and sculptors from Germany, New York, and Milwaukee decorated the interior. St. Benedict's was noted as "Indiana's finest church" and the "city's most magnificent structure."

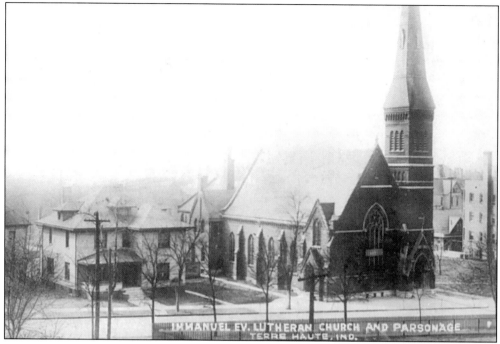

IMMANUEL EV. LUTHERAN CHURCH AND PARSONAGE. The congregation, organized in 1858, built its second and present church, shown here, at 645 Poplar Street. Constructed of solid brick at a cost of $25,000, it was dedicated on October 10, 1886. The site of the parsonage is now occupied by an education building housing the Immanuel Lutheran Preschool.

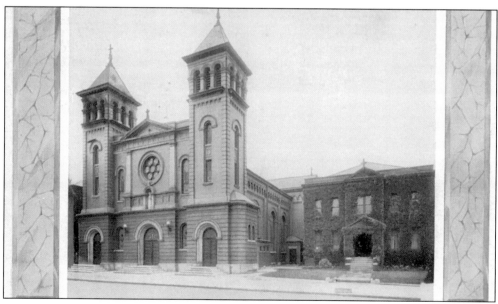

SAINT JOSEPH'S CHURCH. The first Catholic parish in the city, St. Joseph's, was founded in 1837. A frame church was built on the west side of Fifth Street between Ohio and Walnut Streets. This brick building, designed by Jupiter G. Vrydagh, and located on the same site, was dedicated in 1912. It is now the home of St. Joseph University Parish.

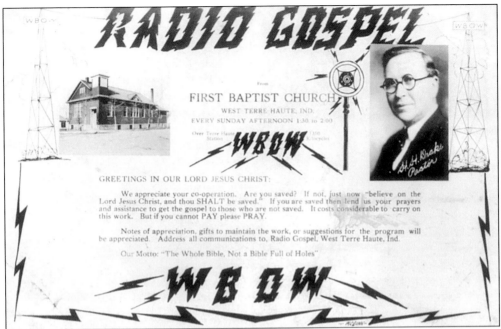

RADIO GOSPEL, WBOW. The West Terre Haute First Baptist Church sponsored a gospel program every Sunday afternoon from 1:30 to 2:00 p.m. over WBOW radio. Harry H. Drake was the pastor and Mrs. Fred Gosnell the radio secretary at the time this card was used in 1934. WBOW was the only radio station in Terre Haute from 1928 until 1948.

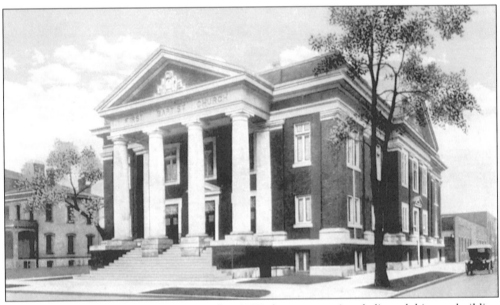

FIRST BAPTIST CHURCH. First organized in 1837, the congregation dedicated this new building at 201 South Sixth Street in 1916. A gymnasium and a swimming pool were included in the structure. The last service was held there in 1968, with the opening of a new church at 4701 Poplar Street. This building was razed for expansion of the Associated Physicians & Surgeons Clinic.

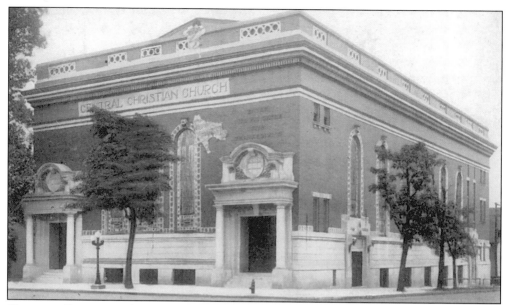

CENTRAL CHRISTIAN CHURCH. The congregation, founded by a group of traveling evangelists in 1841, erected its third church building, shown here in 1911, at the corner of Seventh and Mulberry (now Larry Bird Avenue) Streets. The congregation moved to a new church at 4950 East Wabash Avenue in 1990. The site is now an Indiana State University parking lot.

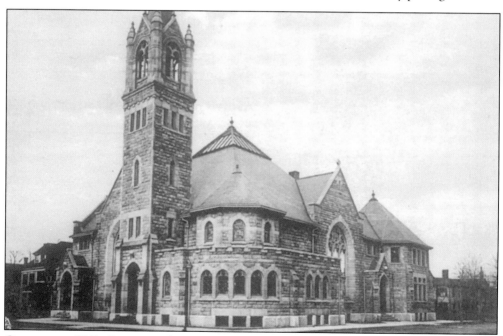

CENTENARY M.E. CHURCH. The congregation of the Centenary Methodist Episcopal Church awarded the contract for a new building at 301 North Seventh Street in 1866, the centennial year of American Methodism. The building was razed and replaced with the one shown here dedicated in 1904. Almost totally destroyed by fire in 1916, the present "New Centenary" was built on the same site and dedicated in 1917.

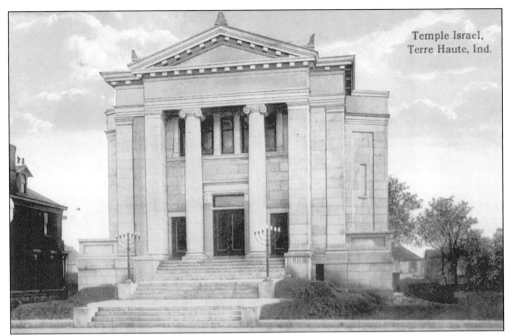

Temple Israel,
Terre Haute, Ind.

TEMPLE ISRAEL. The building committee of Temple Israel accepted plans of Simon B. Eisendrath of New York City in 1910 for a new temple designed in Classical Greek style. It was completed in 1911 at 540 South Sixth Street and now is the home of the United Hebrew Congregation.

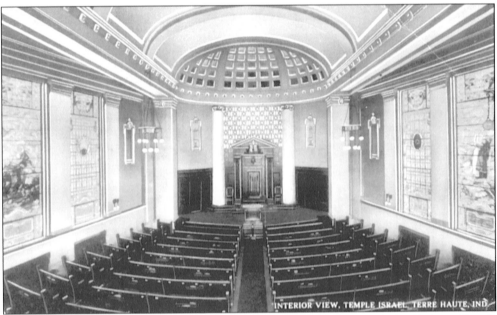

INTERIOR VIEW. TEMPLE ISRAEL. TERRE HAUTE, IND.

INTERIOR VIEW, TEMPLE ISRAEL. The Orthodox B'nai Abraham and the Reform Temple Israel congregations merged in 1935 into the United Hebrew Congregation, which continues to worship in the sanctuary shown here. It was the site of the 150th anniversary of Terre Haute's Jewish Life celebration in 1999.

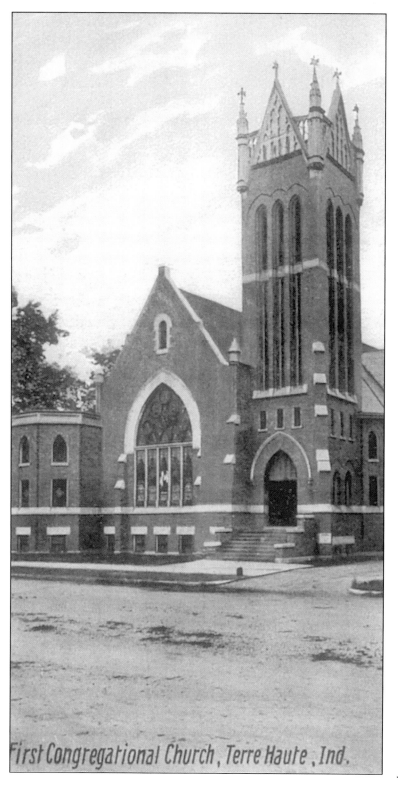

First Congregational Church, Terre Haute, Ind.

FIRST CONGREGATIONAL CHURCH. Established by the Rev. Merrick A. Jewett in 1834, the congregation dedicated this building at 630 Ohio Street in 1903. The architects of the new structure were Trumbull & Jones of Elgin, Illinois, and the general contractor was C. F. Splady of Terre Haute. The 80-foot lot, which together with $8,000 in cash, was secured from Demas Deming in exchange for the old church building and lot at Sixth and Cherry Streets, now the site of Deming Center. The cost of the new Gothic style structure and furnishings was $30,000. The decorative metal and wood details were replaced with brick and stone in 1940, under the direction of Terre Haute architect Juliet Peddle.

ST. STEPHEN'S EPISCOPAL CHURCH.
Organized *c.* 1840, the congregation's
first church building was located
on Fifth Street just north of Wabash
Avenue. Construction of the present
building, pictured here, was begun in
1862, and completed in 1870. The bell
tower was added in 1874, and the great
hall and cloister room in 1891. Bedford
limestone was placed over the original
brick exterior walls in 1906.

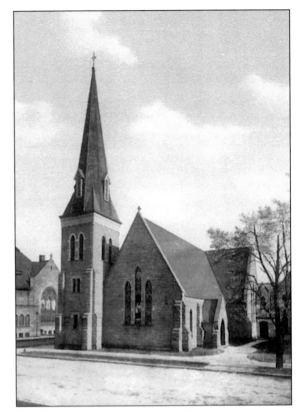

M.E. CHURCH, PRAIRIE CREEK. The congregation of the First Methodist Episcopal Church
in Prairie Creek, established in 1885, erected their own church building in 1894, with George
Rice building the spire and the vestibule. The first two ministers to serve the congregation
were Rev. Leonard Peck and the Rev. John Furry. The building was razed in 1957, and a new
church was constructed.

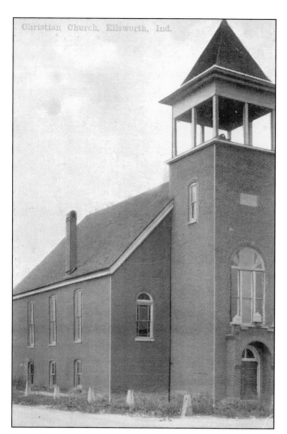

CHRISTIAN CHURCH, ELLSWORTH. The first building of the North Terre Haute Christian Church was dedicated in 1896, and appears on this card used in 1915. The bell tower was later replaced with stairs at the front of the building. The structure was razed and a new building constructed just west of the original Main Street (East Park Avenue) site in 1966–67.

MONTROSE M.E. CHURCH. The message, dated April 20, 1908, reads: "our new church that was just dedicated." This was the home of the Montrose Methodist Episcopal Church at 1100 South Seventeenth Street until the congregation merged with the Otterbein Evangelical United Brethren Church in 1968. The building was then occupied by the Gospel Assembly congregation. It is presently the home of the Greater Victory Temple.

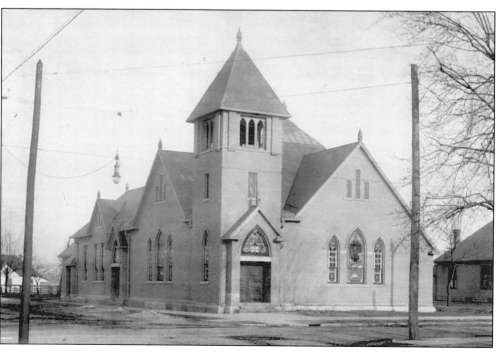

Seven

TRANSPORTATION

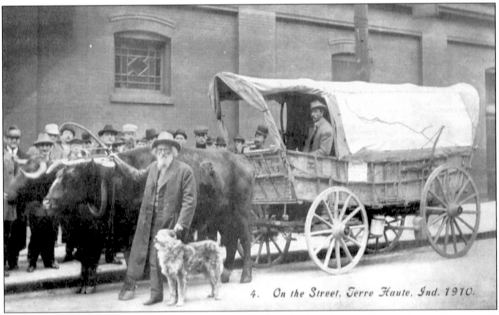

ON THE STREET, TERRE HAUTE, 1910. Ezra Meeker, the bearded gentleman in the foreground, retraced the Oregon Trail route eastward that he had followed to the west in 1852. He traveled 2,630 miles from Washington State to Indiana in a wagon pulled by oxen to urge communities along the way to erect Oregon Trail historical markers. He later marketed postcards showing scenes of his expedition.

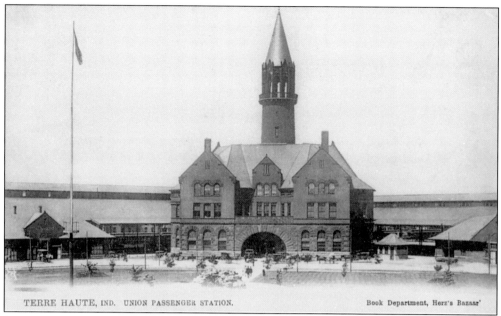

TERRE HAUTE, IND. UNION PASSENGER STATION. Book Department, Herz's Bazaar'

UNION PASSENGER STATION. The Vandalia Railroad's "magnificent new depot," designed by Samuel Hannaford in Romanesque style, opened on August 15, 1893. Three stories high with a 200-foot tower, the red stone and pressed brick structure was razed in 1960. Will Rogers is credited with the quip, "Terre Haute has the only railroad station in the world with a silo in one corner of it." The site on North Ninth Street, between Sycamore and Spruce Streets, is now the Recreation East complex on the Indiana State University campus.

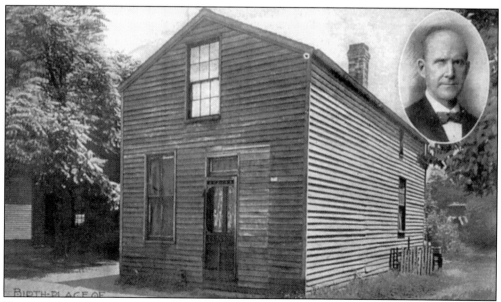

BIRTH-PLACE OF

BIRTHPLACE OF EUGENE V. DEBS. Eugene V. Debs was born in this house at 457 North Fourth Street on November 5, 1855. His boyhood home was the Debs grocery on the northeast corner of Eleventh Street and Wabash Avenue. He attended the city public schools until the age of 14, when he dropped out to work as a painter for the railroad yards.

EUGENE V. DEBS.
Eugene V. Debs became a fireman on the railroad in 1870. He left the railroad in 1874, and was employed as a billing clerk at the Hulman & Cox wholesale grocery firm. He became active in the railroad brotherhoods, served as city clerk, and as an Indiana General Assembly representative. In 1893, Debs organized the American Railway Union, the first industrial union in the United States. Eugene V. Debs was the Socialist candidate for the office of President of the United States in 1900, 1904, 1908, 1912, and 1920. The last campaign was run from prison, where he was serving time for an anti-war speech under

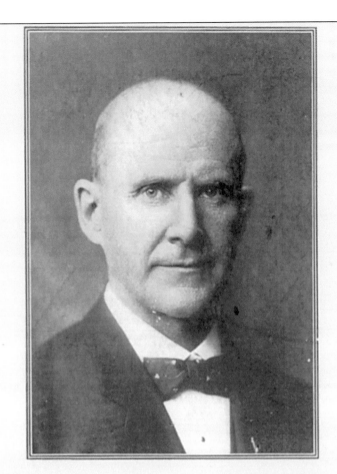

The end of class struggles and class rule, of master and slave, of ignorance and vice, of poverty and shame, of cruelty and crime, the birth of freedom, the dawn of brotherhood, the beginning of MAN, that is the demand. This is Socialism.

the 1917 wartime espionage act. He returned home in 1921, after President Warren G. Harding commuted his sentence to time served. Debs died in 1926. His home at 451 North Eighth Street is maintained as a museum by the Eugene V. Debs Foundation. *Life* magazine (Fall 1990) named Debs "one of the 100 most important Americans of the century—a fiery spokesman for social change. . . eloquently calling for such unheard-of-reforms as social security, the eight-hour day, workmen's compensation, and sick leave."

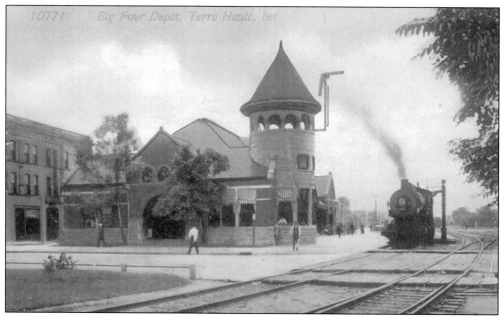

BIG FOUR DEPOT. The Cleveland, Cincinnati, Chicago & St. Louis Railway, popularly known as the Big Four Route, opened this depot in 1899. Located at Seventh and Tippecanoe Streets, it later served the New York Central Lines. Amtrak's National Limited, the last passenger train through the city, was discontinued in 1979. The depot was razed in 1986; the site is now part of the Indiana State University campus.

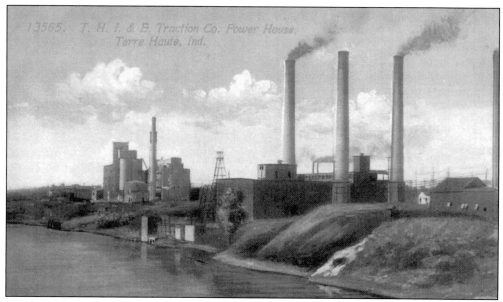

T.H.I.&E. TRACTION CO. POWER HOUSE. The Terre Haute Indianapolis & Eastern Traction Company leased the Terre Haute Traction & Light Company for 999 years in 1907. It operated the Terre Haute, Brazil, Clinton, and West Terre Haute streetcars and the interurban rail lines from Terre Haute. The company power house was located on the southwest corner of North Water and Mulberry Streets.

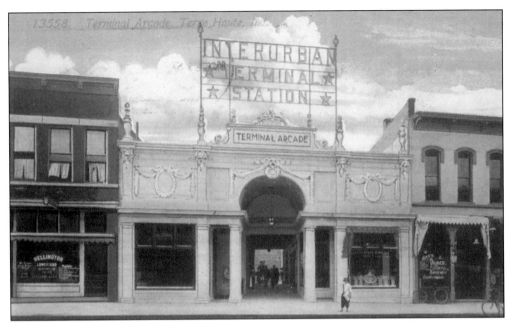

TERMINAL ARCADE. This arcade was constructed in 1911 on the site of the J.S. Evans & Sons bicycle shop by the Terre Haute, Indianapolis & Eastern Traction Company. Located at 820 Wabash Avenue, the building was used as an interurban depot until service was discontinued in January 1940. It served as Terre Haute's union bus station from 1949 to 1972. Terminal Sports and Spirits now occupies the building.

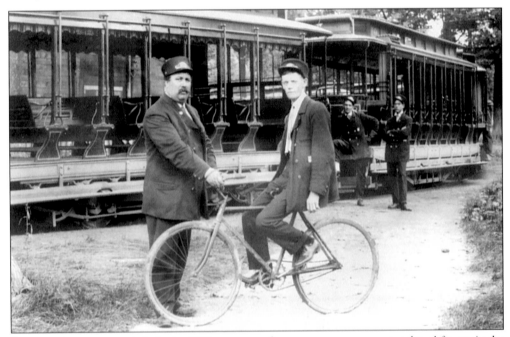

SUMMER STREETCAR. Early in the 1900s, a group of open summer cars was purchased for use in the city. A 1945 *Central Electric Railfans Association Bulletin* reads: "Of course, no American town could resist the pleasures of the summer car, but few had such attractive models as Terre Haute."

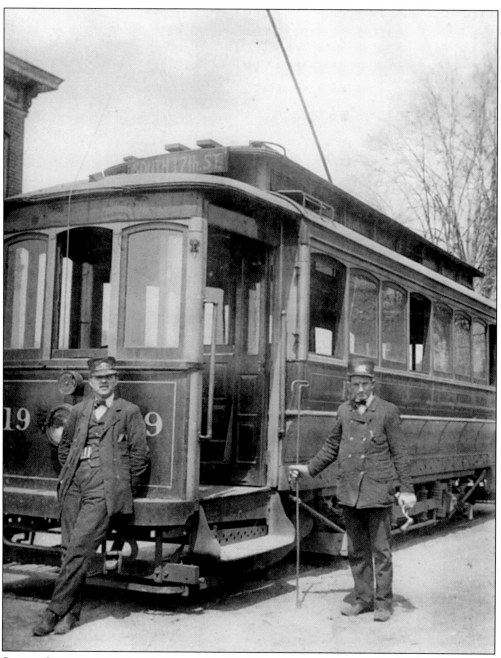

SOUTH SEVENTEENTH STREET LINE. The first line was put into operation by the Terre Haute Street Railway Company in 1867, with two mule-drawn cars travelling from Union Depot to First Street. The system was electrified in 1891, and taken over by the Terre Haute, Indianapolis & Eastern Traction Company in 1907. One of seven routes in 1907, the South Seventeenth Street Line began at Seventeenth and Hulman Streets, ran north on Seventeenth to Crawford Street, west on Crawford to Thirteenth Street, north on Thirteenth to Wabash Avenue and finally west on Wabash to First Street before returning by the same route. Streetcar service was replaced by the Terre Haute City Lines bus service in 1939.

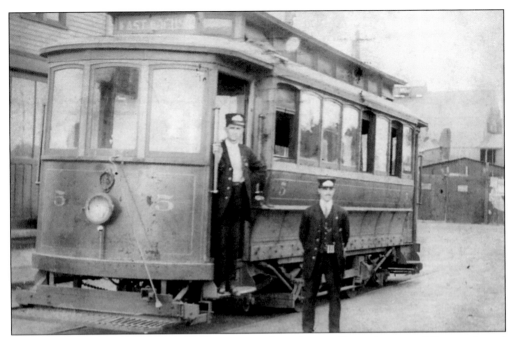

EAST LOCUST AVENUE LINE. This route ran along Locust Street between Nineteenth and Twenty-fifth Streets.

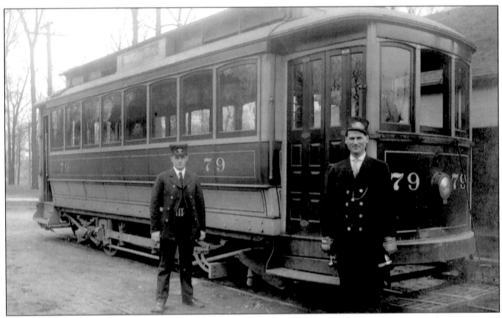

NORTH EIGHTH AND THIRTEENTH STREETS LINE. This route began at Eighth Street and Maple Avenue, ran south on Eighth to Locust Street, west on Locust to Sixth Street, south on Sixth to Wabash Avenue, east on Wabash to Thirteenth Street, and finally north on Thirteenth to Barbour Avenue, before returning by the same route.

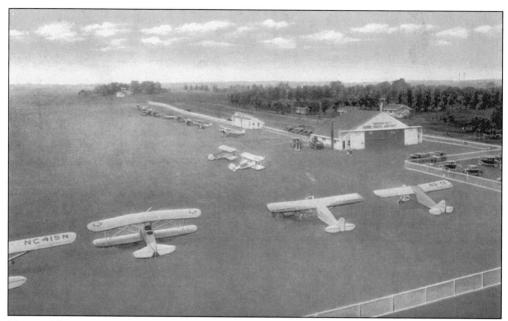

TERRE HAUTE AIRPORT, DRESSER FIELD. Passenger and contract airmail service began in 1928. The field was made the Municipal Airport in 1930 and renamed Paul Cox Field in 1933 in honor of Cox, who had been killed in a plane crash the year before. Closed to air traffic in 1959, the field is now the site of Terre Haute South Vigo High School.

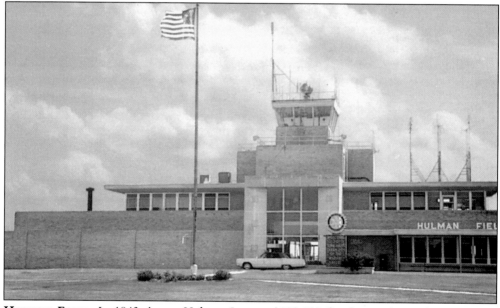

HULMAN FIELD. In 1943, Anton Hulman Jr. gave $100,000 for the purchase of 640 acres of land on East Poplar Street Road for a new airport. The field was dedicated October 3, 1944. The terminal constructed by Roehm Bros., Inc., shown here, replaced the temporary Quonset huts in 1953.

Eight

EDUCATION

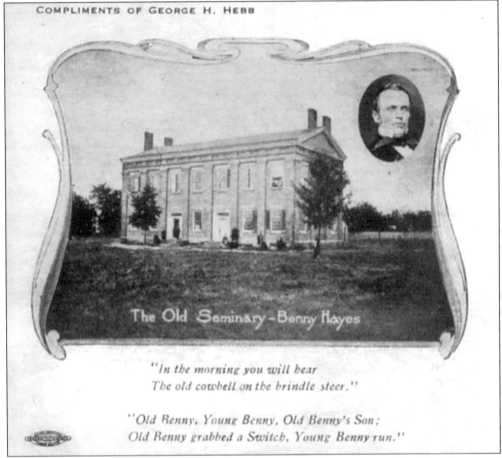

COMPLIMENTS OF GEORGE H. HEBB

The Old Seminary—Benny Hayes

"*In the morning you will hear*
The old cowbell on the brindle steer."

"*Old Benny, Young Benny, Old Benny's Son;*
Old Benny grabbed a Switch, Young Benny run."

THE OLD SEMINARY—BENNY HAYES. Also known as the Vigo County Seminary, it opened in 1847 as a subscription school on the east side of North Sixth Street between Mulberry and Eagle Streets. The second half of the inscription on this card, "Old Benny, Young Benny, Old Benny's Son; Old Benny grabbed a Switch. Young Benny run," may represent the discipline employed by Benjamin Hayes, a teacher at the old Seminary. The structure was razed in 1867 to make way for the Indiana State Normal School Administration building.

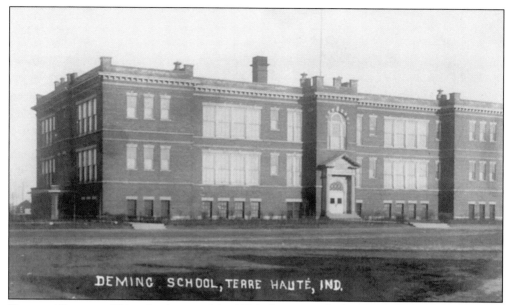

DEMING SCHOOL, TERRE HAUTE, IND.

DEMING SCHOOL. This school opened in 1906, three years before the 1909 postmark on the card. Designed by J.G.Vrydagh, constructed by the John A. Schumacher Company, and named in honor of Demas Deming, it was located on the corner of Sixteenth Street and Eighth Avenue. The school remained in use until November 1978, when the current Deming School at 1750 Eighth Avenue opened.

FAIRBANKS SCHOOL. This elementary school was constructed in 1906 in neo-Jacobethan style, popular for school buildings at the time. It replaced the Nineteenth District School at Fifth and Osborne Streets. The new school was located at the corner of Sixth and Hulman Streets before either street was paved. Named for Crawford Fairbanks, it served students until the new Farrington Grove School opened in 1988.

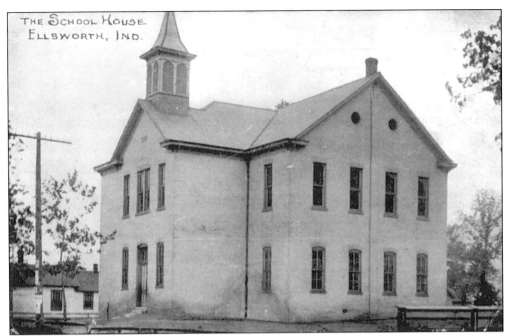

THE SCHOOL HOUSE, ELLSWORTH. Located on Main Street (East Park Avenue) in Ellsworth (North Terre Haute), this card shows the school building after it was improved and a second floor added, about 1904. The building was razed for the construction on the same site of a new Otter Creek Township School, which opened in 1917.

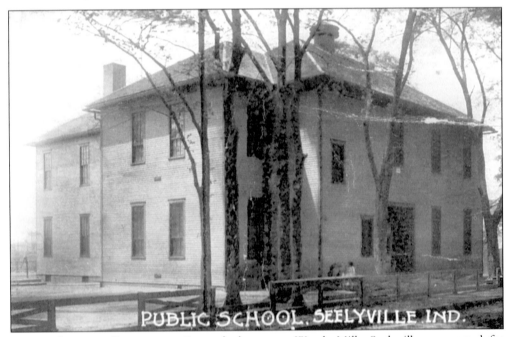

PUBLIC SCHOOL, SEELYVILLE. Formerly known as Woods Mills, Seelyville was named for Jonas Seely, who arrived in Lost Creek Township in 1864. The first school, pictured here, was destroyed by fire in 1918 and replaced with a new structure in 1924.

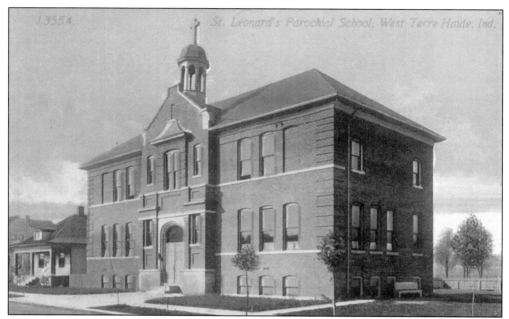

ST. LEONARD'S PAROCHIAL SCHOOL, WEST TERRE HAUTE. St. Leonard's Catholic Church was founded by immigrants of 14 nationalities. This building was erected on North Eighth Street in 1911, to house the church on the top floor and the school below. A new church was constructed in 1959, and the school was closed in the late 1960s. The Knights of Columbus and the Providence Pantry now occupy the building.

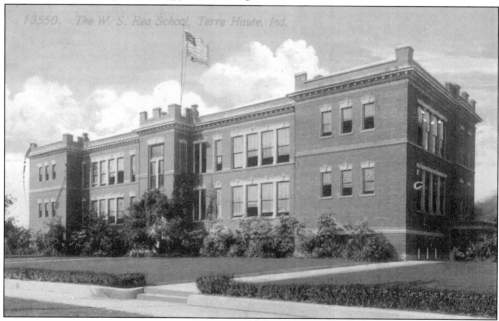

THE W.S. REA SCHOOL. This building was constructed in 1906 to replace a small school housed in a three-room dwelling. Located at 1320 North Fourth Street, the new school was named in honor of William S. Rea, a wholesale merchant and strong supporter of education. The building closed in 1979 and has been razed.

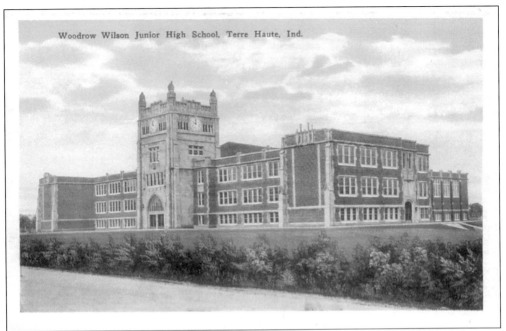

Woodrow Wilson Junior High School, Terre Haute, Ind.

WOODROW WILSON JUNIOR HIGH SCHOOL. Named for Woodrow Wilson, 28th president of the United States, this Collegiate Gothic-style building opened in 1927 at 301 South Twenty-fifth Street. The central foyer contains large murals by Gilbert Wilson. The school was renovated in 1980, and listed on the National Register of Historic Places in 1996. Designed originally as a junior high school, it became a middle school in 1993.

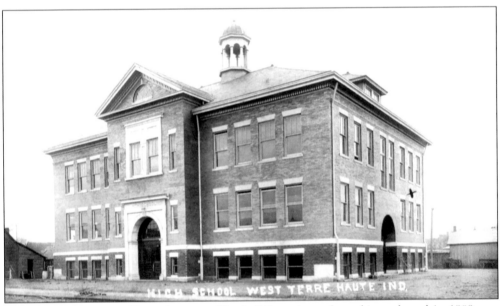

HIGH SCHOOL WEST TERRE HAUTE IND.

WEST TERRE HAUTE HIGH SCHOOL. The building, pictured on this card used in 1909, was constructed in 1908 at the corner of Church and Johnson Streets in West Terre Haute. Twenty-five students were enrolled at the time. Also known as Valley High School, the building was in use until the opening of the new West Vigo High School in 1960.

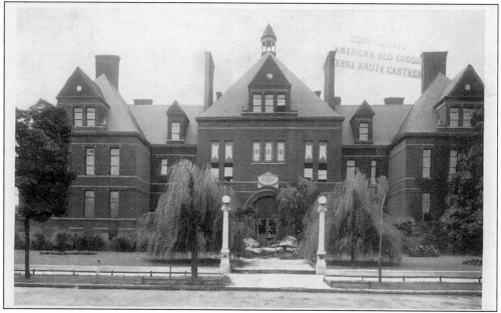

WILEY HIGH SCHOOL. High school classes at the Indiana State Normal School building were moved to the new Terre Haute High School on the southwest corner of Seventh and Walnut Streets in 1886. The name was changed to Wiley High School in 1906, to honor William H. Wiley, superintendent of the City Schools. The last class graduated in June 1971, opening year of the new Terre Haute South Vigo High School.

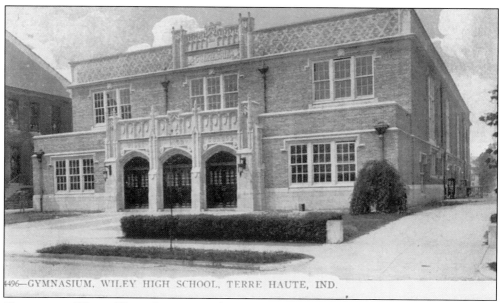

4496—GYMNASIUM, WILEY HIGH SCHOOL, TERRE HAUTE, IND.

GYMNASIUM, WILEY HIGH SCHOOL. Wiley basketball teams practiced in the attic of the high school before the gymnasium was constructed adjacent to the high school building. The new gym opened in 1923, and served as the home to the Wiley Red Streaks until the school closed in 1971. The buildings were razed to make way for the Vigo County Public Library, which opened in 1979.

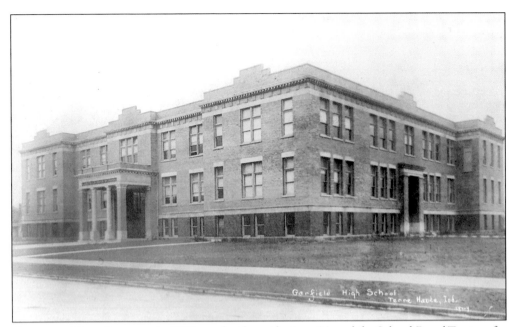

GARFIELD HIGH SCHOOL. In 1909, north side residents petitioned the School Board Trustees for a high school to be built in their part of the city. The new school opened at Maple Avenue and Twelfth Street in 1912. Named to honor President James A. Garfield, it served the Purple Eagles until Terre Haute North Vigo High School opened in 1971. Garfield High School was razed in 1973. Garfield Gardens and Towers occupy the site.

GERSTMEYER HIGH SCHOOL. Rose Polytechnic Institute was housed in this building at North Thirteenth and Locust Streets from 1883 until 1922, when the campus was moved east of the city. At that time, the Boys' Vocational School students were transferred to the building renamed Gerstmeyer Technical High School, in honor of Dr. Charles Gerstmeyer. The girls from the Girls' Vocational School joined the student body in 1925. The school closed when Terre Haute North Vigo High School opened in 1971. The site is now occupied by Chauncey Rose Middle School. Gerstmeyer Memorial Gym, home of the Black Cats, constructed in 1950, remains in use.

103

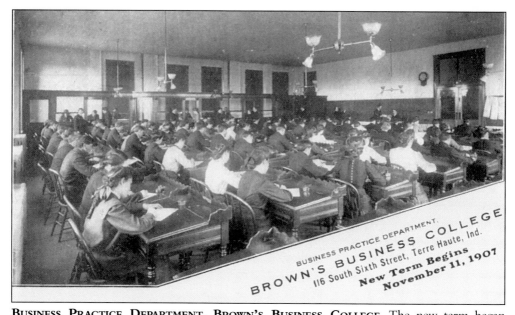

BUSINESS PRACTICE DEPARTMENT, BROWN'S BUSINESS COLLEGE. The new term began November 11, 1907, at this college located in the Arcade Building, 116 South Sixth Street. A 1915 account notes that this college was among the first to admit women as students and to introduce typing, shorthand, salesmanship, and stenotype. It merged with the Wabash Business College in the 1930s to become the Wabash-Brown College of Commerce.

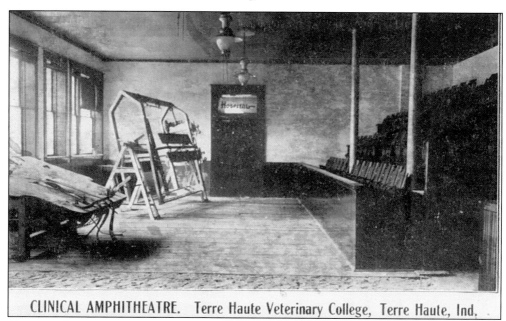

CLINICAL AMPHITHEATRE. Terre Haute Veterinary College, Terre Haute, Ind.

CLINICAL AMPHITHEATER, TERRE HAUTE VETERINARY COLLEGE. Dr. S.V. Ramsey, an 1889 graduate of the Chicago Veterinary College, moved his practice from Tuscola, Illinois, to Terre Haute in 1896. He opened his hospital on the northeast corner of Third and Poplar Streets in 1899. A 1900 description reads, "the best equipped in the state for accommodation of sick horses, cattle and dogs." It became a veterinary college in 1909.

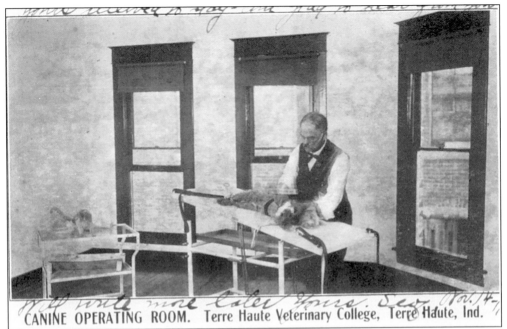

CANINE OPERATING ROOM. Terre Haute Veterinary College, Terre Haute, Ind.

CANINE OPERATING ROOM, TERRE HAUTE VETERINARY COLLEGE. Prospective students were told that "the government alone would employ more inspectors than the entire number of graduates from all recognized (veterinary) colleges," and "city and county practice (also) offers a large territory—areas embracing whole counties are without a veterinary." The two cards on this page are dated 1911.

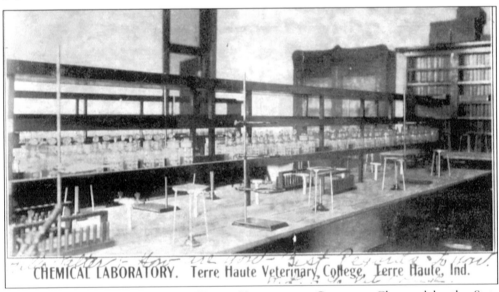

CHEMICAL LABORATORY. Terre Haute Veterinary College, Terre Haute, Ind.

CHEMICAL LABORATORY, TERRE HAUTE VETERINARY COLLEGE. Chartered by the State of Indiana in 1909 and located at 222–228 South Third Street, it was said to be "a thoroughly modern school of veterinary science." The course required three terms of six months each. Dr. C.I. Fleming was the dean. The college closed in 1919. A McDonald's restaurant now occupies the site.

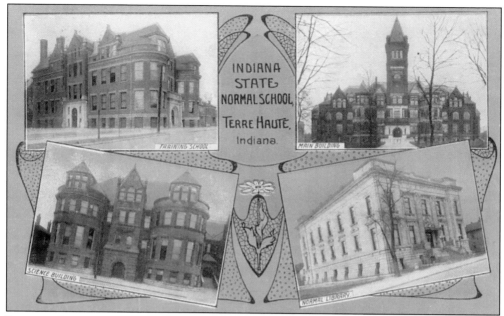

INDIANA STATE NORMAL SCHOOL. Founded in 1865 as a training school for teachers, the first students, 21 in number, enrolled in 1870. These photos, clockwise from top left are: the Training School (613–625 Mulberry), the main building on the east side of North Sixth Street between Mulberry and Eagle Streets, the Science Building (626 Eagle Street), and the Normal Library (640–646 Eagle Street).

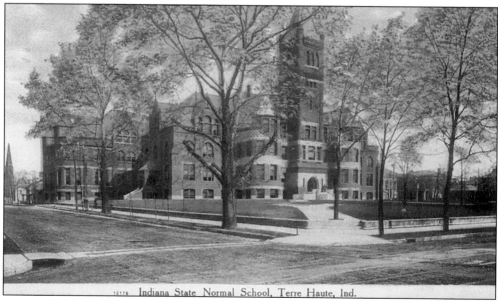

Indiana State Normal School, Terre Haute, Ind.

INDIANA STATE NORMAL SCHOOL. After fire destroyed the original building in 1888, this main building was constructed on the foundation in 1889. North Hall was added in 1895. The building remained in use until 1950, when it was razed. The name of the institution was changed to Indiana State Teachers College in 1929, to Indiana State College in 1961, and to Indiana State University in 1965.

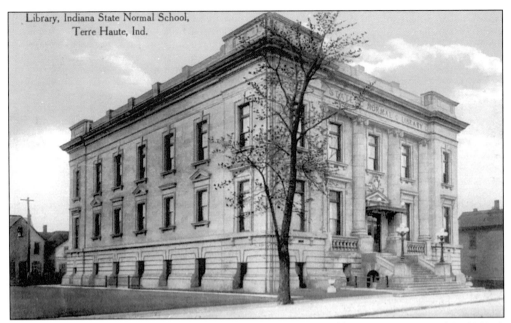

LIBRARY, INDIANA STATE NORMAL SCHOOL. The library building was constructed in 1910. A six-story addition was completed in 1957. In 1965, it was named in honor of Arthur Cunningham, Normal librarian, and remained in use as the library until the new Cunningham Memorial Library opened in 1973. It is now Normal Hall.

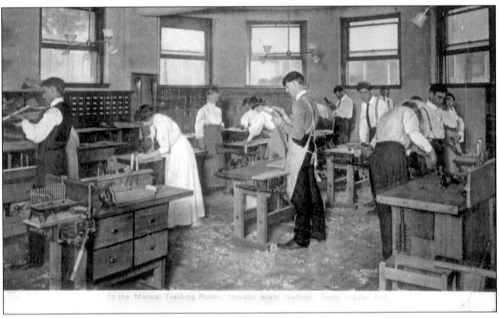

IN THE MANUAL TRAINING ROOM, INDIANA STATE NORMAL. The 1905 catalogue was the first to mention manual training. Courses in woodwork, suited for teachers of the seventh and eighth grades and the lower classes in high school, were offered. Cabinetmaking was added later. The manual training department, shown on this card used in 1911, had been headed by Merit L. Laubach since its establishment six years before.

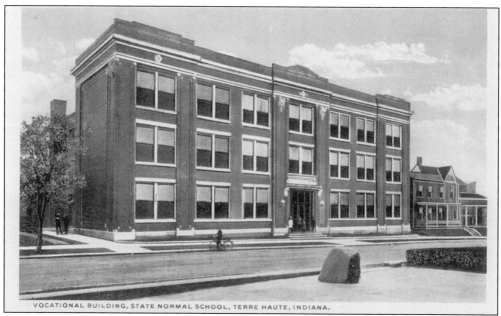

VOCATIONAL BUILDING, STATE NORMAL SCHOOL, TERRE HAUTE, INDIANA.

VOCATIONAL BUILDING, STATE NORMAL SCHOOL. The manual training courses were offered in the basement of the first training school, built in 1905, until this Vocational building for the industrial arts and home economics departments was completed in 1915. The message, written in 1919, reads: "I am taking Textiles, Household Physics, Home Care of the Sick, English and Gymnasium."

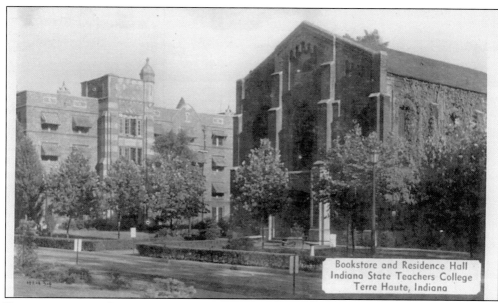

Bookstore and Residence Hall
Indiana State Teachers College
Terre Haute, Indiana

BOOKSTORE AND RESIDENCE HALL, INDIANA STATE TEACHERS COLLEGE. The bookstore was located in the former First Christian Church building on Mulberry Street between Condit House and the Women's Residence Hall. The dormitory, completed in 1925 (later expanded and named Reeve Hall), was the first residence building on the campus. The bookstore was razed in 1954 and Reeve Hall in 1997.

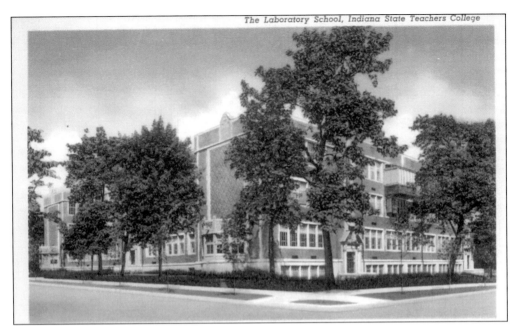

THE LABORATORY SCHOOL, INDIANA STATE TEACHERS COLLEGE. The new training school was constructed with federal Works Progress Administration funds in 1935, on the northeast corner of Seventh and Chestnut Streets. The south entryway contains small murals by renowned artist Gilbert Wilson. It housed State High School until 1978, and the University School until 1991–92. It is now University Hall.

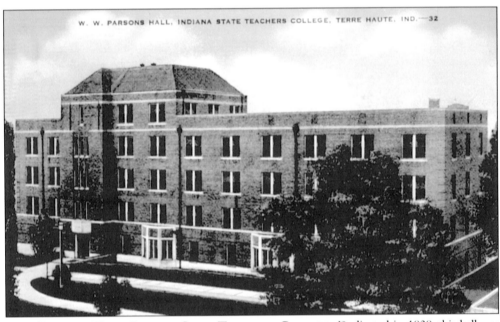

W.W. PARSONS HALL, INDIANA STATE TEACHERS COLLEGE. Dedicated in 1939, this hall was constructed to house 125 male students under "model college living conditions." It was named in honor of William Wood Parsons, third president of the institution. It later became an office and classroom building before it was razed in the early 1990s.

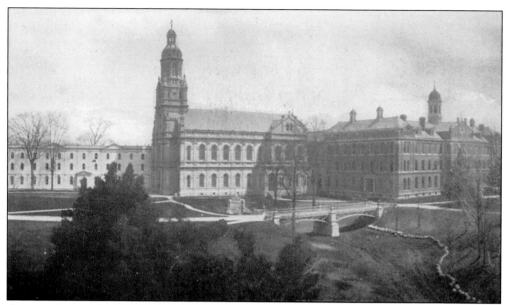

CHURCH OF THE IMMACULATE CONCEPTION. The 11-bell chimes ring out from the church every quarter hour over the wooded campus shared by the Sisters of Providence and Saint Mary-of-the-Woods College (located in Sugar Creek Township, northwest of Terre Haute). Completed in 1891, this Italian Renaissance structure, patterned after the Church of the Holy Trinity in Paris, was consecrated in 1907 and renovated in 1987.

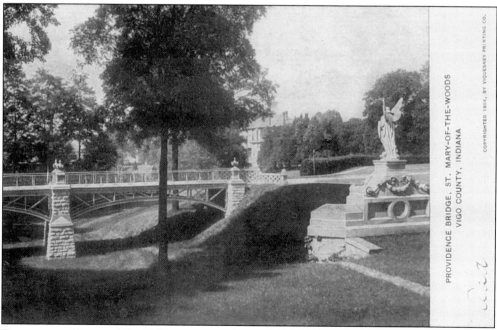

PROVIDENCE BRIDGE. The 1907 message reads:"A most beautiful place."This bridge once divided the campus between the Sisters of Providence on the east side and Saint Mary-of-the-Woods College on the west. A path across the ravine replaced the bridge in 1989. The statue of Saint Michael the Archangel, at the right, remains in place.

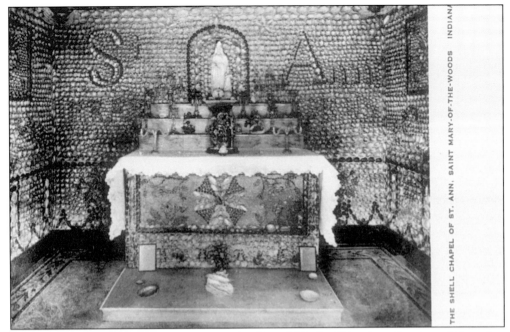

THE SHELL CHAPEL OF ST. ANN, SAINT MARY-OF-THE-WOODS INDIANA

THE SHELL CHAPEL OF ST. ANN (SIC). The Blessed Mother Theodore Guerin and five other Sisters of Providence left their religious community in France in 1840, to travel to Thralls Station, Indiana, which would become St. Mary-of-the-Woods. A small log chapel, erected in 1844 in devotion to St. Anne, was replaced with a stone building in 1876. The interior is decorated with shells gathered from the Wabash River.

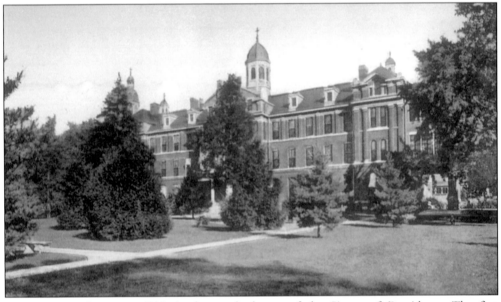

PROVIDENCE CONVENT. This is the motherhouse of the Sisters of Providence. The first motherhouse, built by the Blessed Mother Theodore Guerin in 1853, was destroyed by fire in 1889. Providence Convent, erected on the same site, was completed in 1890. The building remains in use today.

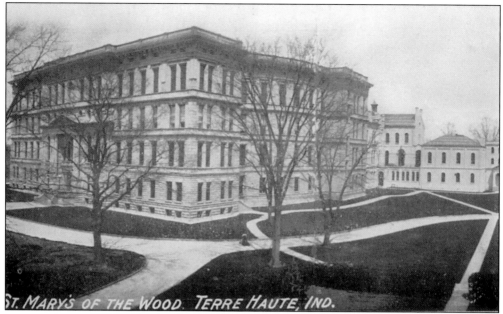

FOLEY HALL. Originally named Central Hall, the construction of this Renaissance Revival building began in 1860. The three-story, three-wing sections were completed in 1868. Thirty years later, the four-story Indiana limestone front section was added. Listed on the National Register of Historic Places in 1985, Foley Hall was closed in 1988 and razed in 1989. Providence Center, built in 1990, occupies the site.

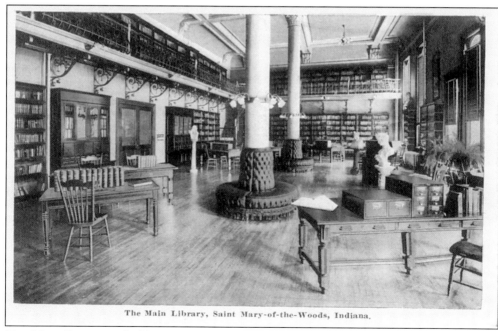

The Main Library, Saint Mary-of-the-Woods, Indiana.

THE MAIN LIBRARY. The library was located on the second floor of Foley Hall. The specifications required that the settees around the columns be upholstered with dark green furniture leather. The present library, built of Bedford limestone, was completed in 1964.

112

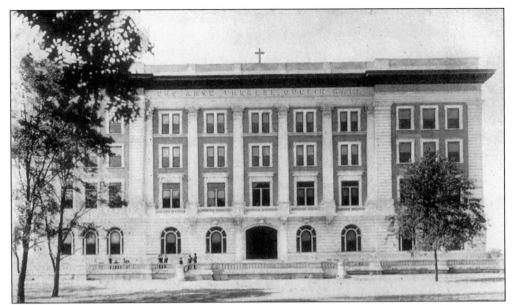

GUERIN HALL, NEW COLLEGE BUILDING. The construction of Guerin Hall and the Conservatory of Music, between 1911 and 1913, greatly expanded the facilities on campus. Private and semi-private rooms for students on the top three floors of Guerin Hall moved away from the traditional dormitory system and followed a new trend in campus housing at the time.

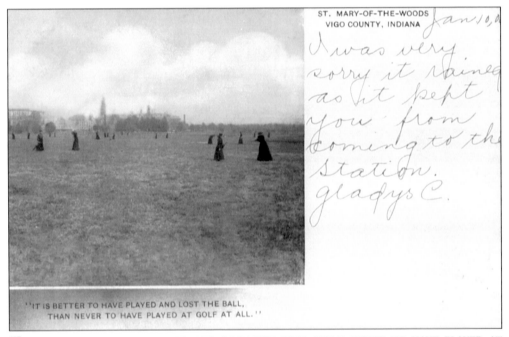

ST. MARY-OF-THE-WOODS
VIGO COUNTY, INDIANA

Jan 10, 0

I was very sorry it rained as it kept you from coming to the station.

Gladys C.

"IT IS BETTER TO HAVE PLAYED AND LOST THE BALL,
THAN NEVER TO HAVE PLAYED AT GOLF AT ALL."

"IT IS BETTER TO HAVE PLAYED AND LOST THE BALL, THAN NEVER TO HAVE PLAYED AT GOLF AT ALL." Students playing golf on the campus are pictured on this card published in 1906. The course met its doom during World War II, when it was converted into soybean fields. Central (Foley) Hall, St. Agatha's Hall, the Church of the Immaculate Conception, and Providence Convent appear in the background.

CHAUNCEY ROSE PLAQUE, ROSE POLYTECHNIC INSTITUTE. Terre Haute industrialist Chauncey Rose sought to found a school in the Midwest to teach technical education. On September 10, 1874, the "Terre Haute School of Industrial Science" was incorporated. Rose soon donated substantial funding and a parcel of land on the northwest corner of Thirteenth and Locust Streets. The class of 1911 erected this bronze plaque to commemorate the founding.

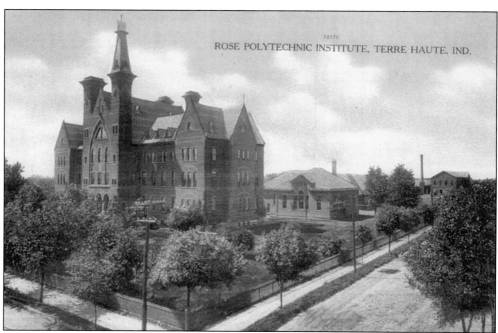

ROSE POLYTECHNIC INSTITUTE. The cornerstone was laid on September 11, 1875, and the name was formally changed to Rose Polytechnic Institute over the protest of Mr. Rose. The firm of McCormick and Sweeney was awarded the contract for the four-story brick building over a basement. It contained 46 rooms and opened for classes in March 1883, with the first graduation in 1885.

114

ROSE POLYTECHNIC INSTITUTE. This card, used in 1908, shows the second chemical laboratory on the left and the gymnasium on the right. The first chemistry lab burned in 1895. Always on the lookout for entertainment, in 1912, the chemists adopted "Rosaniline Ammonia," a cat who hung around the labs. Her life was short, but the present Alpha Chi Sigma Professional Chemistry Fraternity chapter has adopted a toy version as a traveling mascot.

PENNANT, ROSE POLYTECHNIC INSTITUTE. Many traditions surround the school, including Rosie the elephant mascot, inter-class rivalries, freshmen beanies in use through the early 1970s, and the continuing homecoming bonfire. Another long-standing Rose tradition changed in 1995, with the admission of women.

TRACK MEET, ROSE POLYTECHNIC INSTITUTE. This track meet took place on the track just to the northwest of the main building.

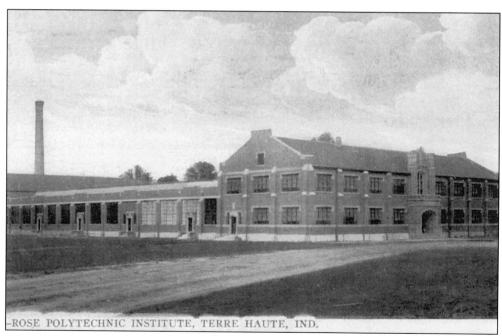

⌐ROSE POLYTECHNIC INSTITUTE, TERRE HAUTE, IND.

ROSE POLYTECHNIC INSTITUTE. By 1910, it was realized that a new building was needed. In 1922, the school moved to its current campus, east of the city on land donated by the Hulman family. The old Rose building then became the home of Gerstmeyer Technical High School. Rose Polytechnic Institute became Rose-Hulman Institute of Technology on December 31, 1970.

Nine

DISASTERS

FONTANET. On Tuesday morning, October 15, 1907, disaster struck the town of Fontanet in Nevins Township. The Laflin and Rand mill, operated by the DuPont Powder Company, exploded. The mill produced blasting powder for use in area coal mines. A series of four explosions left huge holes and broken trees at the mill site south of town. One blast was recorded more than 200 miles away.

MONAHAN HOME, FONTANET. General Superintendent A.B. Monahan was among those killed in the plant office. Mrs. Monahan and her sister were also killed in the nearby family home, which was completely destroyed by the blast.

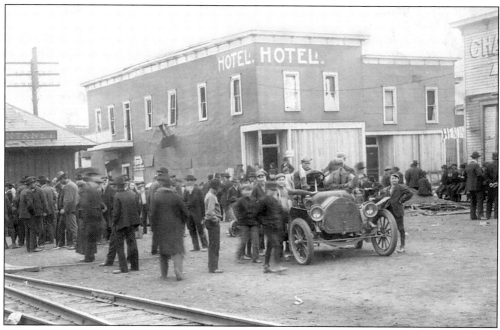

FONTANET. Men and boys gathered around the car of Indiana Governor J. Frank Hanly, who personally came to Fontanet to view the devastation left by the explosion. No building in the town was left free of damage. The churches, schools, depot, and business buildings were destroyed. Damage was estimated at $350,000.

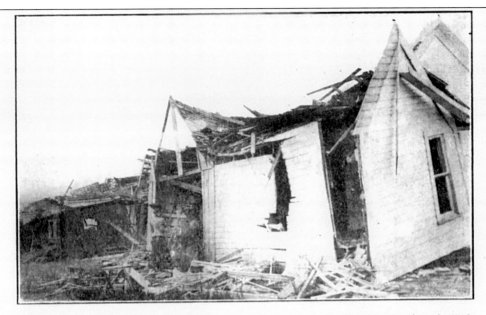

SOUVENIR – DuPont Powder Mill Explosion, Fontanet, Ind., Tuesday, October 15, 1907

SOUVENIR—DuPont Powder Mill Explosion, Fontanet, Ind., Tuesday, October 15, 1907. When the final count was determined, more than two dozen persons were killed and more than a hundred severely injured. Damage extended to the nearby towns of Carbon, Cardonia, and Coal Bluff.

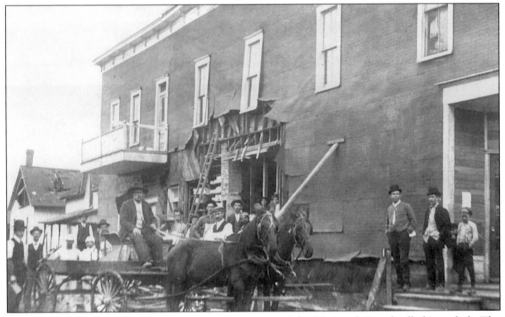

Fontanet. Disaster relief funds were rapidly set up and the National Guard called in to help. The town was rebuilt, but not with another powder mill. At a meeting five days after the explosion, citizens made it clear they did not want the company to return.

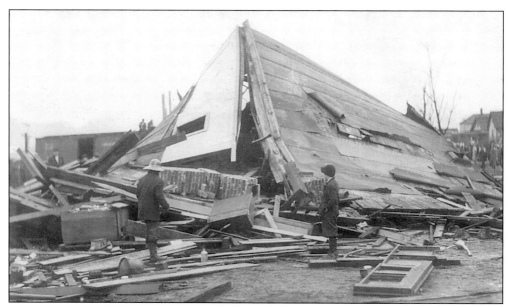

1913 TORNADO. A beautiful Easter Day turned into a tragic evening in Terre Haute. On Sunday, March 23, 1913, at about 10 p.m., a tornado with winds of more than 100 miles an hour, roared into the city from the southwest and left a path of destruction. The message on this card reads: "This house was blown against a bunch of freight cars. You can see one of the cars standing. The others were smashed like the house."

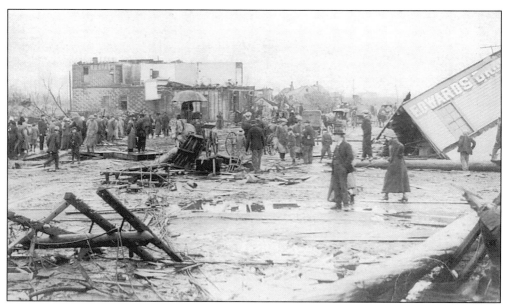

1913 TORNADO. The Edwards Drug Company Store, 2400 South First Street (at the corner of Vorhees), was one of the businesses destroyed. The young son of E.J. Edwards was one of the 17 fatalities of the storm.

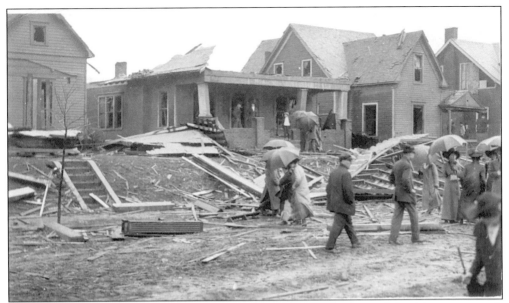

1913 TORNADO. "The house shown here was a two story one. All that was left of the upper story is what you see laying on the ground," is the message written on the back of this postcard.

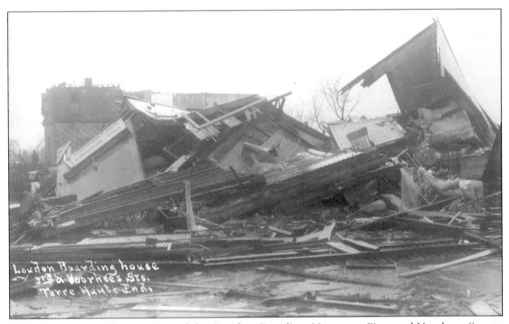

1913 TORNADO. The remains of the Louden Boarding House, at First and Voorhees Streets, are shown here. The new Greenwood School, located nearby, became a rescue station and a morgue.

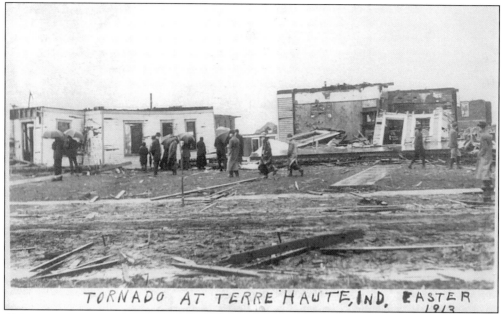

TORNADO AT TERRE HAUTE, IND, EASTER 1913

1913 TORNADO. Destruction was not limited to homes and stores. Factories, such as Johnson Brothers Motors Company, Gartland Foundry, and the Root Glass Company, were either damaged or destroyed. Soon thereafter, the flooding began.

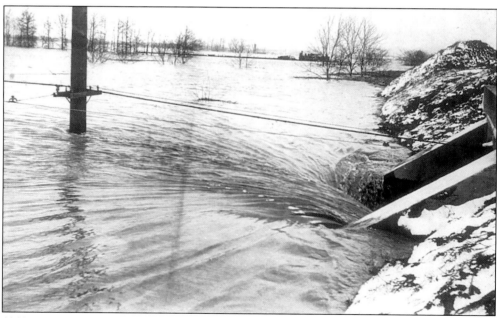

1913 FLOOD. Disaster struck twice during the last week of March 1913—first a devastating tornado, then the flood with the Wabash River cresting at 31 feet, 10 1/2 inches. The Sugar Creek and Taylorville (Dresser) levees gave way to major flooding west of the river. When the levee north of Terre Haute broke, homes on the northwest side of the city were flooded.

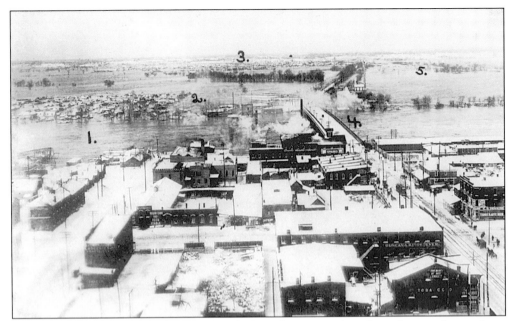

1913 FLOOD. The flooded areas are identified on this scene taken from the courthouse dome looking west: 1. Wabash River, 2. Taylorville (Dresser), 3. West Terre Haute, 4. Wabash River Bridge, and 5. Vandalia Railroad grade.

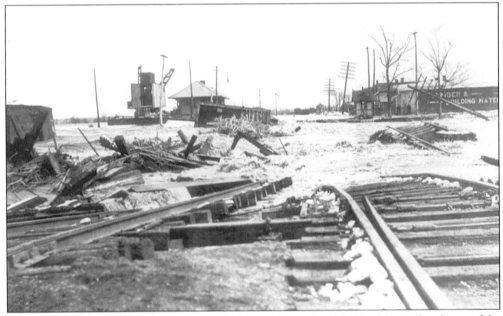

1913 FLOOD. The steady rush of water washed away the grade of the Vandalia Railroad west of the river. Soon the tracks gave way, and water swept through the town of West Terre Haute.

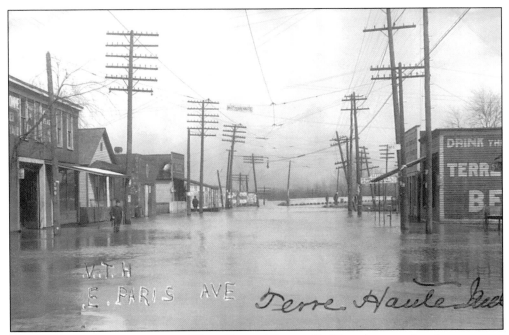

1913 FLOOD, EAST PARIS AVE., WEST TERRE HAUTE. By Thursday morning the water was 2 feet deep along Paris Avenue. Between 1 and 2 feet of water stood in the stores. The mines and clay factories had closed, leaving several thousand persons out of work. About 4,000 persons were left homeless.

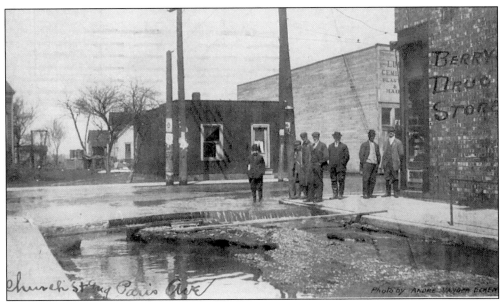

1913 FLOOD, CHURCH (SECOND) STREET AND PARIS AVENUE, WEST TERRE HAUTE. George Berry and friends were looking south at the flood damage on the side of Berry's Drug Store. By Friday, the water had begun to recede. Four more deaths, these attributed to the flood, were added to the week's toll.

Index